SECRET NORTHWICH & AROUND

Adrian and Dawn L. Bridge

AMBERLEY

Also by the Authors

A–Z of Northwich & Around: People, Places, History (Amberley Publishing, 2019)
Northwich & Around in 50 Buildings (Amberley Publishing, 2021)
Chester's Military Heritage (Amberley Publishing, 2021)

First published 2022

Amberley Publishing
The Hill, Stroud
Gloucestershire, GL5 4EP

www.amberley-books.com

Copyright © Adrian and Dawn L. Bridge, 2022

The right of Adrian and Dawn L. Bridge to be
identified as the Authors of this work has been
asserted in accordance with the Copyrights, Designs
and Patents Act 1988.

ISBN 978 1 3981 0380 1 (print)
ISBN 978 1 3981 0381 8 (ebook)

British Library Cataloguing in Publication Data.
A catalogue record for this book is available from the
British Library.

Origination by Amberley Publishing.
Printed in Great Britain.

Contents

Introduction

For much of its pre-industrial history Northwich was a miniscule, but economically important, township consisting of little more than 6 statutory acres of land dotted with salt pans and wych houses (where salt was produced). From the mid-nineteenth century onwards, however, Northwich expanded, aided by the profits of the salt industry, shipbuilding and the development of the alkali industry in the 1870s. The once tiny township of Northwich began to absorb neighbouring townships such as Leftwich, Witton, Hartford and elsewhere, and this process of expansion continued until well into the twentieth century, so that the modern town of Northwich now stretches a good few miles out into the Mid Cheshire countryside. *Secret Northwich & Around* contains references to both the old, miniscule Northwich, centred around the area of the Bull Ring, and to the 'greater', expanded Northwich with its interlinked parishes and townships such as Lostock Gralam, Davenham and Rudheath. The emphasis throughout this book (in keeping with its title) has been to focus upon lesser-known aspects of the area's history. Thus, the Northwich area's involvement in, and reaction to, nineteenth-century Britain's wars in the Crimea, the Sudan, and South Africa will be considered. The reader will also learn more about the 1885 election night disturbances in central Northwich, which were so serious and violent that the military were nearly brought in to clear the streets and keep order. Similarly, although many know something about the Northwich area's links to the history of slavery and the slave trade, we hope to provide the reader with a much more detailed appreciation of the scale and diversity of those links.

In order to uncover some of the often forgotten people and events of bygone Northwich and around, the authors spent some six months ploughing through a range of local, national and, occasionally international, newspapers, covering the period between 1850 and 1950. These sources provide some enlightening glimpses of the Northwich area during a period of immense change. The newspapers were certainly happy to report upon the escapades of the social elite, including the various Cholmondeley barons of Delamere, who were undoubtedly the Northwich area's most colourful and controversial aristocrats. The adventures (and misadventures) of the Cholmondeley family through the best part of a hundred years – from near drownings in a Northwich duck pond to murder in Kenya – will be chronicled in some depth during the course of the coming pages. Newspapers of the time also reported on the less fortunate, such as the homeless and hungry people who wandered the streets of the area and sought entry to the Northwich Workhouse. Policing and crime, then as now, were a major topic of press attention, along with the plethora of infectious diseases that plagued Northwich and its surrounding parishes during this period. Using this contemporary press coverage, and aided by medical reports and other primary sources, the authors hope that an entertaining yet informative picture emerges of some of the lesser-known aspects of the history of Northwich and around.

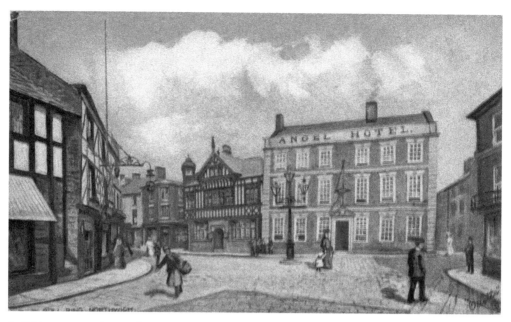

Bull Ring, *c*. 1903. (© Lauder collection of Raphael Tuck & Sons postcards)

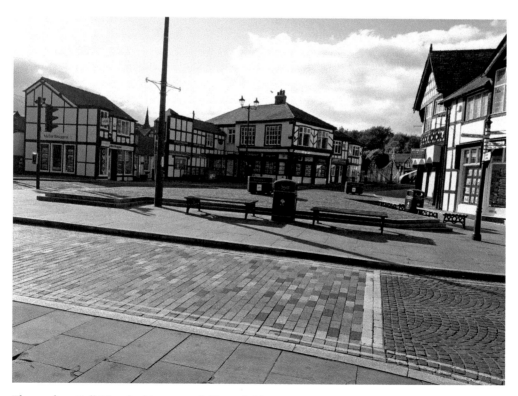

The modern Bull Ring, looking towards Town Bridge.

1. The 'Profits' of Slavery

The issue of slavery hit the headlines in Britain, America and across the world during 2020. The Black Lives Matter campaign had won adherents in many countries and activists toppled statues of historical figures linked to slavery in many different locations. Within the UK, many towns and cities have links to the dark days of the slave trade, when British families, traders and companies profited from the capture and sale of black men, women and children, who were packed into slave ships on the West African coast and transported to work on sugar, cotton and other plantations of the Caribbean and the Americas. Even a comparatively small town like Northwich, together with its surrounding satellite villages, benefited considerably from the vast profits made from Britain's involvement in the slave trade. Of course, Northwich is situated right in the heart of Mid Cheshire, roughly 25 miles inland from Liverpool, one of the world's great historic port cities, so it's not really surprising that the links between the Northwich area and the slave trade are quite significant and long-standing.

The area's most active ex-slave trader was undoubtedly William Harper, an influential Liverpool merchant who undertook fifty-two voyages (all on slave-trading business) between 1784 and 1799. Harper acquired lucrative plantation interests at the Molineaux estate, on the British Caribbean island colony of Montserrat, and he used this income, together with his more general slave-trading profits, to fund the purchase of Davenham Hall, just a couple of miles south of Northwich township, in 1795. Harper seems to have taken on the role of squire of Davenham with some alacrity, and he was soon assuming responsibility for the appointment of a schoolmaster at Davenham village's second aided school, on Church Street. By the time of his death, in 1815, William Harper had accrued a fortune of some £7,000 (roughly equivalent to over £625,000 today) from his slave-trading activities, which he bequeathed to his son-in-law, John Hosken Harper, who became the new squire of Davenham. During the early 1820s, John Hosken Harper used much of this inherited wealth to carry out a substantial building programme at Davenham Hall, and the fine Georgian edifice that we see today is very much the product of this construction project.

With the exception of William Harper, the slave and plantation owners of the Northwich area were largely absentee landlords, who controlled their estates via letter and written instructions. The most prominent of these absentee landlords was probably Richard Pennant, 1st Baron Penrhyn, who owned Winnington Hall, just a mile or so to the north of Northwich township, between 1771 and 1808. Pennant was MP for Liverpool for a total of nineteen years, between 1767 and 1790, and owned five plantations in Jamaica (Cote's, Denbigh, King's Valley, Kupuis and Thomas River), which produced sugar, rum, molasses and cotton, and on which livestock was bred. These plantations probably housed a total of nearly 2,000 slaves, and produced substantial profits, some of which Pennant used to build an impressive new neoclassical wing at Winnington Hall, in 1775.

Davenham's second aided school, now a theatre.

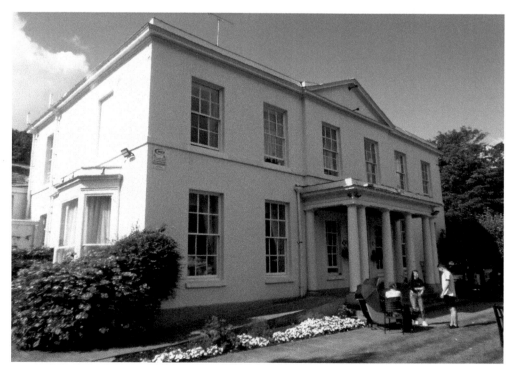

Davenham Hall (front exterior).

Davenham Hall's opulent central stairway.

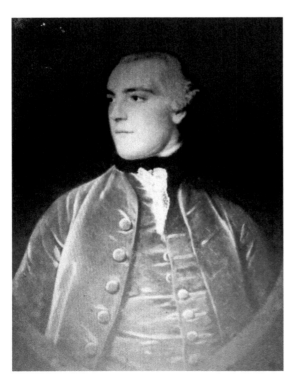

Richard Pennant, Baron Penrhyn, by
Joshua Reynolds, 1761.

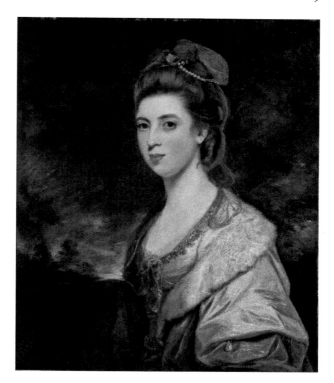

Mrs Richard Pennant, by Joshua Reynolds, 1816.

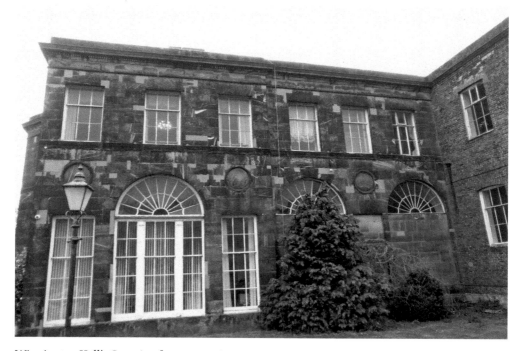

Winnington Hall's Georgian front extension.

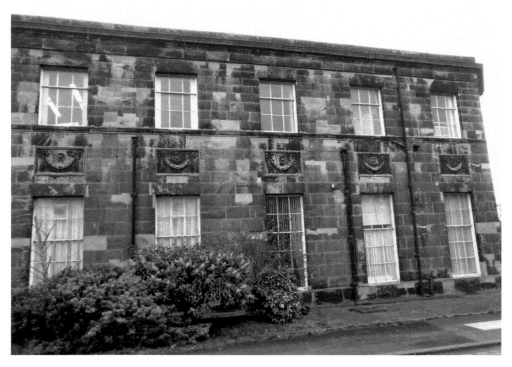

Winnington Hall's Georgian rear extension.

Richard Pennant was a stern opponent of the abolition of slavery, and he used his position as an MP and as the chairman of the London-based Standing Committee of West Indian Planters and Merchants (between 1785 and 1808) to oppose the ending of slavery at every turn. By the time of his death in 1808, Pennant was allegedly over £150,000 in debt. Winnington Hall was sold to cover some of this debt, and parts of his Welsh estates were also mortgaged. The Jamaican estates were, however, looked upon as being indispensable, and every effort was made to keep them intact and within the family. In this endeavour, Richard Pennant was entirely successful, as both slaves and plantations were eventually inherited by his cousin, George Hay Dawkins.

Both Pennant and William Harper were Northwich-based slave owners during the period when slavery was still legal in the colonies of the British Empire. Other slave owners in the Northwich area, however, still owned slaves in 1833, when the British government made slavery illegal in most, but not all, parts of the burgeoning British Empire. The Act of Parliament that abolished slavery came into force during 1834, and, subsequently, the British government compensated all plantation owners for the loss of their slaves via the introduction of the 1837 Slave Compensation Act. Though no money at all was offered to compensate ex-slaves for the wrongs done to them, owners were offered a remarkably generous compensation package. In total, some £20,000,000 was awarded to slave owners, and between 40–50 per cent of this money was paid to approximately 3,000 individuals and families in the UK (the rest went to overseas plantation owners). This was

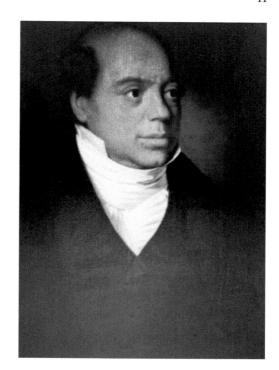

Nathan Rothschild, by Morita
Oppenheim, 1853.

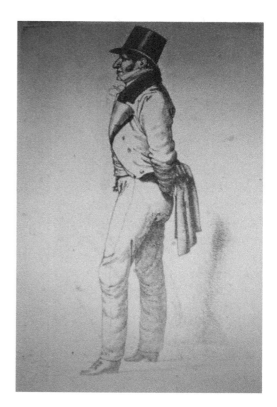

Sir Moses Montefiore, by Richard Dighton the
Younger, 1818.

a huge sum in the 1830s, and represented roughly 40 per cent of the British Treasury's entire budget at the time. So vast were the overall sums handed out to slave owners in the Northwich area, and in the rest of the country, that the British government needed outside help in order to meet its financial obligations. Two enormously rich financiers, Nathan Rothschild and Sir Moses Montefiore, were called in to underwrite government loans of £15,000,000, while the government itself contributed a further £5,000,000.

Did You Know?
Compensation was paid to slave owners in Northwich and elsewhere despite the fact that most slaves remained at the owners' plantations even after being given their freedom. Though these black workers were no longer referred to as slaves, they remained under the control of plantation owners as very poorly paid 'apprentices', with few rights and little chance of any real economic independence.

This officially sanctioned compensation package provided a substantial stimulus to the micro-economy of Northwich and around. Slave owners in the Northwich area received widely differing amounts of compensation. For example, John Hosken Harper of Davenham Hall received £714 in compensation for the 'loss' of the forty-two slaves acquired from his father-in-law's Montserrat estate. However, the Hosken Harper's nearby gentry neighbours, the France-Hayhurst family, received a far greater sum for the loss of their slave-owning interests. Thomas France was a wealthy Liverpool merchant and slave owner who acquired enough wealth to purchase the substantial Bostock Hall, near Davenham, during the late 1790s. Thomas and his children went on to hold major plantation interests, particularly in Jamaica. James France France (one of Thomas's sons) was given £4,223 in compensation for the 'loss' of roughly 240 slaves at the family's Ludlow estate in Clarendon, Jamaica. James had also been the joint owner of the smaller Jamaican Friendship Hall estate, which possessed between sixty-four and seventy-two slaves.

The France-Hayhurst family became incredibly wealthy as a result of its involvement in slavery, plantations and other commercial and property ventures. James France France invested money and time in Bostock Hall, as did his younger brother, Thomas France-Hayhurst, who enjoyed a successful clerical career, and became rector of St Wilfrid's Church in Davenham. When James France France died in 1869, he left the huge sum of £100,000 in his will. Another brother, Henry Hayhurst-France, also left £100,000 when he died in 1875. Revd Thomas Hayhurst-France succeeded to all the family's estates, including Bostock Hall, after the death of his brother James France France. Not surprisingly, therefore, Thomas outdid all his brothers, in monetary terms, by leaving a personal estate valued at the staggering sum of over £133,000 when he died at Davenham Rectory in November 1889.

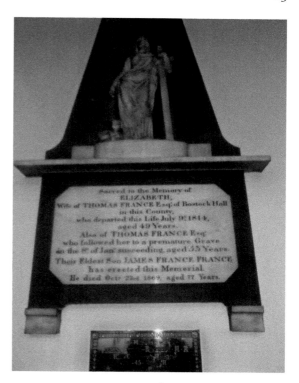

France family memorial from
St Wilfrid's Church.

St Wilfrid's Church.

The France-Hayhursts linked themselves to the Hosken-Harpers via marriage to become Davenham's dominant gentry family – a family alliance sealed by the marriage of Helen Hosken Harper (daughter of John Hosken Harper) to Revd Thomas France Hayhurst. The two families involved themselves in many acts of charity and good works in the local area, such as the building of Davenham's third aided school in 1856, on the junction of Hartford Road and London Road. John Hosken Harper donated the land on which the school was to be built, and Thomas France-Hayhurst paid just under half the total costs of the new school building project. When John Hosken Harper died in 1865, his son erected a memorial fountain in honour of his father, which still stands today at the junction of London Road and Fountain Lane. It was a memorial that befitted the status of one of the Northwich area's leading gentry figures. However, as with the France-Hayhursts, it was a status derived (at least in part) from a decidedly murky slave-owning past.

The legacies of slavery in the Northwich area are to be found not just in impressive memorials and Georgian residences – there were commercial and industrial legacies as well. Sir Hardman Earle, 1st Baronet of Allerton Towers, lived very briefly in a comparatively modest residence at Mersey Vale, on Chester Road, in Hartford, from 1874 until his death in 1877. Earle came from a Liverpool family with major slave and plantation interests in Antigua. Hardman's father, Thomas Earle, was a merchant and slave owner who had been mayor of Liverpool in 1787–88, and left an estate valued at £70,000 at the time of his death in 1822. His son, Hardman, was already a rich young man

Davenham's third aided school.

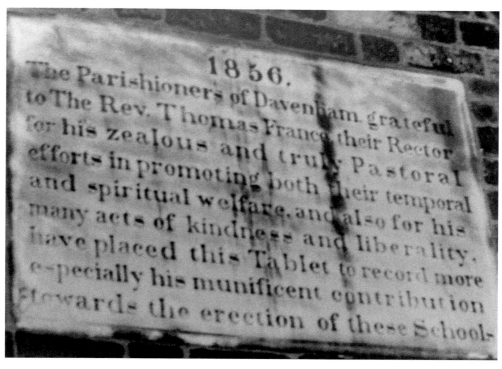

School building commemorative tablet.

List of contributors to third aided school.

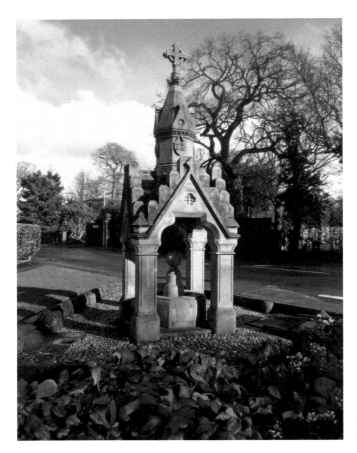

Hosken-Harper Memorial
Fountain.

when he became wealthier still as a result of the compensation he received for the 'loss' of his slaves in Antigua. Hardman Earle made successful compensation claims for the 'loss' of 1,158 slaves at six Antiguan plantations (Lynch's, Blizard's, Bodkins St Paul, Thibou's, Gunthorpe's and Manning's), which netted him the tidy sum of over £11,000. Although much of Earle's money was spent on the family estate at Allerton Towers in Liverpool, and Mersey Vale cost him £1,600, he also invested heavily in railway stocks, and he was one of the financial driving forces behind the companies building the tracks and viaducts that began to criss-cross the landscape around Northwich during the mid-nineteenth century.

Not all the former slave owners of the Northwich area left clear, definable legacies behind them, be it in terms of grand Georgian mansions, businesses or monuments. The four Coulthurst sisters, for example – Catherine Constantia, Mary, Elizabeth and Maria – led quiet, unobtrusive lives in the Northwich area for over sixty years. From at least 1841 onwards, the sisters lived at Sandiway Cottage in Weaverham, and the last surviving sister (Mary) died at the cottage in 1898. The sisters led respectable, affluent lives, which were rarely reported upon by the local newspapers of the time. Nevertheless, the ladies were part of a substantial slave- and plantation-owning family with business interests in Barbados and Guyana. One of their uncles, Henry Coulthurst, was a Yorkshire

Hardman Earle, *Illustrated London News*, 1877.

Mersey Vale, as seen from Chester Road.

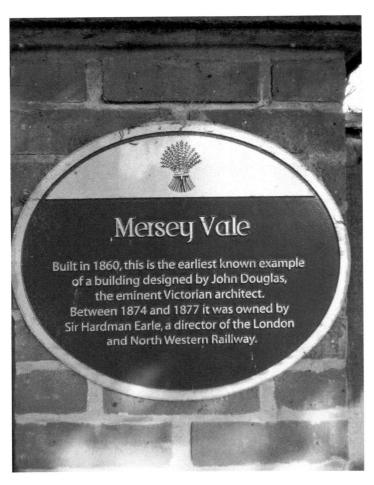

Mersey Vale plaque.

vicar, and a friend of the abolitionist William Wilberforce. Despite this, Henry still managed to maintain a lucrative business interest in a sugar plantation in Guyana. His Weaverham nieces – Catherine, Maria, Mary and Elizabeth – were also the co-owners of a major Barbados plantation, of 301 acres, called Baker's, which another uncle, Matthew Coulthurst, purchased for over £8,000 in 1806. At the time of this purchase, Baker's already possessed 127 slaves, and as a result of the 1837 Slave Compensation Act, each of the Coulthurst sisters received £3,072 for the 'loss' of their Baker's slaves. The four sisters then carried on as the owners of Baker's, until they finally sold the plantation to Georgiana Gibbons in 1851.

All the Coulthurst sisters managed their personal finances with considerable success. When Maria Coulthurst died, in Llandudno in 1873, she left personal effects worth £7,000 and an estate valued in excess of £17,000. When Mary Coulthurst died in 1898, she left an estate worth in excess of £35,000 (roughly equivalent to around £4.5 million today), which she left in its entirety to an unrelated but very fortunate vicar named Edmund Lally Roxby.

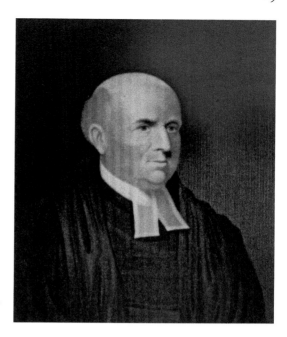

Henry Coulthurst, 1818. (© Bridwell Library
Special Collections)

Map of Barbados, 1817.

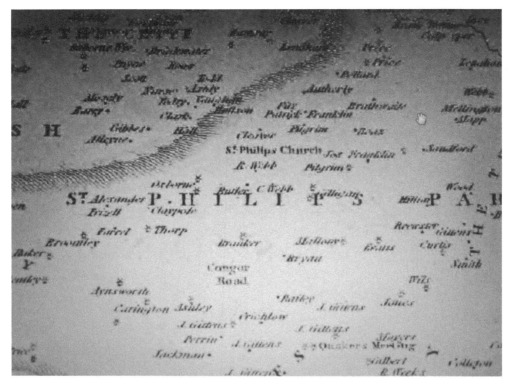

Close-up of map, showing Bakers (west) and Sandford (east) plantations, 1817.

Another slave-owning family, the Ashtons, lived close to the Coulthursts in Weaverham. In his will of 31 December 1814, John Ashton's place of residence was given as The Grange, Weaverham, where he lived with his wife, Mary, and family. In the late 1790s, John Ashton owned the Guilsbro estate in Jamaica, which possessed a watermill and cattle, and also produced rum and sugar. In 1809, the estate was documented as having 233 slaves. In addition, Ashton had £16,600 of Jamaican property mortgages in his possession, which he left in trust for his seven children, together with some land in Staffordshire. John Ashton also married into a major Jamaican plantation and slave-owning family. In 1790, he married Mary Jarret, the daughter of John Jarret, who was either the mortgage holder or owner of seven Jamaican plantations. The marriage alliance ensured that much of Jarret's slave and plantation profits flowed into the hands of the Ashton family. Mary herself came to John Ashton with a marriage settlement of £10,000, supplied by her father. John, in turn, left this money in trust to the seven surviving children of his marriage to Mary Jarret (Mary Jr, Harriet, Herbert, William, Richard, Frederica and Julia). John Jarret also supplied his favourite grandchildren with even more money and gifts. For example, £3,000 was left in a trust fund for Harriet Ashton. The interest on this sum was earmarked for her education and maintenance, and she could pick up the rest of the capital when she was either married or reached the age of twenty-one. Jarret also left £3,000 to young William Ashton.

All seven of the Ashton children led very comfortable lives, financed in no small measure by the slave and plantation profits generated by their father and grandfather. The girls made some magnificent marriages, which took them far from Weaverham. Julia Ashton married Captain Hugh Berner, who was the son of the Archdeacon of Suffolk, and they lived together in the opulent surroundings of Eaton Square, Westminster, with their every whim catered for by five servants. Frederica Ashton made an even more magnificent marriage, when she became the wife of Frederick Baring, grandson of the founder of Baring's Bank. Frederica, Frederick and their children lived in some splendour in Belgravia, Westminster, with a governess and eleven servants.

Did You Know?
Not all John Ashton's children travelled far from Weaverham. Richard Ashton moved just a few miles to Gorstage Hall, where (in the 1851 census) he was recorded as being a landed proprietor, managing 45 acres of land with the assistance of his wife, five household servants, two coachmen, and two labourers.

No account of the historical impact of slavery upon the Northwich area would be complete without a reference to Robert Heath, the owner of Hefferston Grange, near Weaverham, for roughly fifty years, between the late 1850s and 1907. Heath owned approximately 260 acres of land around the Grange and was seen as a major figure in Mid Cheshire landed society. His death, in August 1907, aged eighty-three, was reported in a wide range of newspapers across the country. Heath was obviously successful in his chosen occupation as a landed proprietor, leaving a massive estate valued at over £40,000. Newspapers like the *Manchester Courier* were also interested in Heath's more distant past as a significant cotton plantation owner in the southern states of America prior to the onset of the American Civil War. Uniquely among the slave owners of the Northwich area, Heath's predominant business concerns lay not in the British Caribbean colonies, but within the hotbed of slavery that was the American South. The exact nature of Heath's cotton interests in the Southern states of America is difficult to determine. However, once the civil war began in 1861, it's unlikely that his businesses prospered. The Union blockade of the South, which began almost immediately the war started, destroyed 95 per cent of the South's cotton business virtually overnight. Heath's enterprises were almost certainly one of the many that collapsed, and it's no surprise that in the post-civil war period Robert Heath's priorities seemed to have focused entirely upon the development of Hefferston Grange and its associated lands.

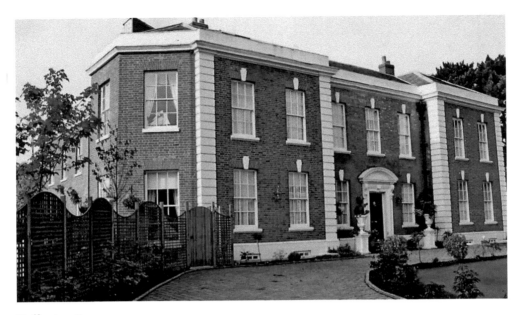

Hefferston Grange.

2. Democracy and Disorder in Victorian Northwich

The town of Northwich first gained its own defined Parliamentary electoral presence, distinct from the ancient hundreds of Cheshire, as a result of the 1885 Redistribution of Seats Act. This particular Parliamentary Act created the new electoral constituency of Northwich, which had a total population of around 60,000, of whom approximately 10,000 males had the right to vote. Although the new constituency took the name of Northwich, it included other salt and industrial towns along the River Weaver, such as Runcorn. John Brunner, co-founder of the Brunner-Mond alkali empire, was principally responsible (along with some other leading liberals) for the division being named as Northwich, and he stood as the Liberal Party's candidate to be Northwich's first MP in the general election of December 1885. He was opposed by the Conservative Party's candidate, William Henry Verdin, a member of the wealthy Verdin family who'd made considerable fortunes from the local salt industry.

Sir John & Lady Jane Brunner.
(© Catalyst Widnes)

The Liberal Party meeting (held at the Drill Hall in Leftwich, in April 1885) that decided who was to stand as the candidate for Northwich proved to be a fiery, rambunctious affair. Brunner's rival to be the Liberal candidate for Northwich was none other than Robert Verdin, the elder brother of the Conservative candidate, William Henry Verdin. Though Brunner won the vote to be selected as the Liberal candidate, ahead of Robert Verdin, both he and Robert coped with much heckling and catcalling from a boisterous Liberal audience assembled at the Drill Hall. The animosity between Brunner and Robert Verdin was plain for all to see, and after losing the Liberal selection vote, Robert refused to back Brunner in the subsequent Northwich election campaign, and he accused the alkali boss of rigging the voting procedure at the Drill Hall meeting. The December election campaign that followed proved to be quite vicious in tone, and made many other more modern elections in the town seem rather tame by comparison. Much of the language used was vitriolic and discriminatory, and would be deemed unacceptable to the vast majority of a more modern Cheshire electorate. John Brunner's foreign extraction (he was the son of a Swiss minister) was highlighted, as was the alleged guttural, Germanic inflexion in his voice. There were also obvious anti-Semitic overtones apparent in the criticisms made of Brunner's close links to Ludwig Mond, his German-Jewish business partner.

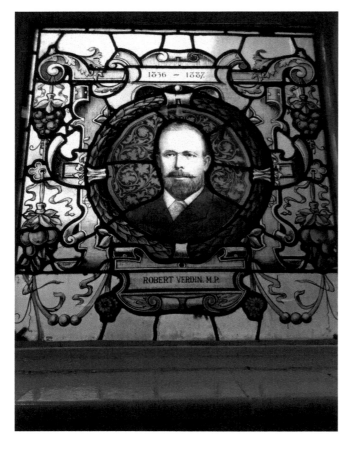

Robert Verdin, from the Verdin Technical Schools, 1897.

A teenage Ludwig Mond (right) in Germany *c.* 1856. (© Archiv des Corps Rhenania, Heidelberg)

Did You Know?
John Brunner was criticised for his links with Ludwig Mond throughout his entire political career. Such criticisms might have reached a crescendo during the years of the First World War, had the local population realised just how much money Mond had spent on buying artworks, in partnership with the German scholar Henriette Hertz. Together, they had filled the Palazzo Zuccari in Rome with priceless treasures, which were eventually donated to the German Kaiser, Wilhelm II, in 1913 (just one year before Britain declared war on Germany).

More legitimately, Brunner was often asked to account for and justify working conditions at his alkali works in Winnington, and cutting jibes were made about the so-called 'white slaves of Winnington'. In general, though, Brunner seemed to be better received in towns like Northwich and Runcorn than he was in the countryside. When he made speeches in rural areas such as Great Budworth, he often fell victim to the antics of agricultural labourers, who would drown out his words, heckle and march in and out of his meetings during visits to the local ale house.

Henriette Hertz. (© Max Planck Institute, Rome)

Palazzo Zuccari, Rome. (© Manfred Heyde)

John Brunner also had to cope with the opposition of Irish nationalists. All political elections, across the ages, have their key issues, from war and unemployment to Brexit in the twenty-first century. In the mid-1880s, however, in Northwich and across the country, the burning issue was Home Rule for Ireland. Brunner was a supporter of Home Rule, and his Conservative opponent, William Verdin, was not. Despite this, the famous Irish Nationalist leader Charles Stewart Parnell had done a deal with Lord Salisbury, and national Conservative party leaders. As part of this rather bizarre deal, Parnell contemplated standing an Irish Nationalist candidate as MP in Northwich, to oppose Brunner. The nationalist likely to stand was identified as being Fox O'Carrell from Chester, and a Parnell representative actually visited Northwich to pursue the matter further. The Parnell scheme didn't get far, however. The unfortunate representative who visited Northwich on Parnell's behalf was surrounded by an angry mob outside the hotel where he was staying. The mob threatened to throw the man through one of the hotel windows unless he left Northwich. Sensibly, perhaps, no more was heard of the plan, and the Parnell representative left Northwich in rather hasty fashion.

In addition to Conservatives, anti-Home Rule Liberals and some Irish nationalists, Brunner also faced opposition from local clergymen who opposed his plans to 'disestablish' the church by severing the link between the state and the Church of England. By the time of election day in Northwich, on 1 December 1885, a tense and rather febrile atmosphere enveloped the town. Violence was anticipated in a locality notorious (at least according to the *Manchester Guardian*) for its rowdy behaviour and 'rough play' at election times. As dusk fell, shops began to board up their premises. The free library, funded by Brunner,

Unionist political poster, 1893. (© Hugh Manfred)

Charles Stewart Parnell, c. 1880. (© Library of Congress)

had already been closed and boarded up in anticipation of violence. Brunner's supporters, many of them Irish immigrants who supported his pro-Home Rule sentiments, were also on the streets of central Northwich, and had taken over and destroyed the Conservative Party's election headquarters building. Every window in the building was smashed, and frightened clerks narrowly escaped injury (as did William Verdin, the Tory candidate, who fortuitously managed to leave the building just before the mob arrived). Crowds also assembled at the Town Bridge, and some of those who gathered apparently laid plans to intercept a brass band expected at the bridge (who might have been musical supporters of either Brunner or Verdin) and throw all their instruments into the river.

The Northwich constabulary of the time clearly believed that the town was out of control. Under the terms of the 1715 Riot Act (only repealed and revised in 1967) gatherings of twelve or more people could be construed as being unlawful assemblies, which could be dispersed by 'punitive' action. In the case of the Northwich police, this punitive action took the form of a truncheon charge. Eighty constables, led by the chief constable of Cheshire, Captain Hammersley, repeatedly charged the crowds. With truncheons drawn, the police waded into the crowds, and scattered them. At least one old man, named Evans, was injured severely by a police staff, on his own doorstep, and two policemen also needed medical attention after being hit by stones. So unsure were the civil authorities of

(243)

Anno Primo

Georgii Regis.

An Act for Preventing Tumults and Riotous Assemblies, and for the more speedy and effectual Punishing the Rioters.

Whereas of late many Rebellious Riots and Tumults have been in divers Parts of this Kingdom, to the Disturbance of the Publick Peace, and the Endangering of His Majesties Person and Government, and the same are yet continued and fomented by Persons Disaffected to His Majesty, presuming so to do, for that the Punishments provided by the Laws now in being are not adequate to such Heinous Offenders ; and by such Rioters His Majesty and His Administration have been most Maliciously and Falsly traduced, with an Intent to raise Divisions, and to Alienate the Affections of the People from His Majesty : Therefore for the Preventing and Suppressing of such Riots and Tumults, and for the more speedy and effectual Punishing the Offenders therein. Be it Enacted by the Kings most Excellent Majesty, by and with the Advice and Consent of the Lords Spiritual and Temporal, and of the Commons in this present Parliament Assembled, and by the Authority of the same, That if any Persons to the Number of Twelve or more, being Unlawfully, Riotously, and Tumultuously Assembled together, to the Disturbance of the Publick Peace, at any time after the last Day of July, in the Year of our Lord One thousand seven hundred and fifteen, and being Required or Commanded by any one or more Justice or Justices of the Peace, or by the Sheriff of the County, or his Under-Sheriff, or by the Mayor, Bailiff or Bailiffs, or other Head Officer, or Justice of the Peace of any City or Town-Corporate, where such Assembly shall be, by Proclamation to be made in the Kings Name, in the Form herein after directed, to

I P p p 2 disperse

The 1715 Riot Act. (© Jay Dillon Rare Books)

THE RIOT ACT.

If any persons to the number of 12 or more unlawfully, riotously, and tumultuously assemble together to the disturbance of the public peace and being required by any Justice by proclamation in the King's name in the exact form of the Riot Act, I George I, Sess. 2 c. 5 s. 2, to disperse themselves and peaceably depart, shall to the number of 12 or more unlawfully, riotously and tumultuously remain or continue together for an hour after such proclamation shall be guilty of a felony.

The Form of Proclamation is as follows :—

"Our Sovereign Lord the King chargeth and commandeth all persons, being assembled, immediately to disperse themselves, and peaceably depart to their habitations, or to their lawful business, upon the pains contained in the Act made in the first year of King George the First for preventing tumults and riotous assemblies."

GOD SAVE THE KING.

Riot Act proclamation.

30

the situation in Northwich that a telegram was sent to Chester Castle asking for military assistance in quelling the disturbances, though a later telegram was sent cancelling the request, once it seemed Hammersley had the situation under control. Police actions did succeed in dispersing the crowds, and by the following morning the town was back to normality. Northwich's first and probably most violent election campaign was over. It was an election won by John Brunner, by 1,028 votes, and it ended as controversially as it had begun, when William Verdin refused to congratulate Brunner on winning the epic struggle to become the Northwich constituency's first MP.

The new MP for Northwich had little time to rest on his laurels, however, because the new Liberal government soon collapsed under the pressure of trying to secure Home Rule for Ireland. Liberal Unionists split from the rest of the Liberal Party, and the embattled Liberal government tried to gain a new mandate for its Home Rule policies by calling a general election, which took place in August 1886. In Northwich, Robert Verdin stood as the Liberal Unionist candidate, opposed to Irish Home Rule, and John Brunner tried to defend the seat he'd recently won on behalf of the official Liberal Party. Many of the same arguments for and against Home Rule, and for and against John Brunner, were repeated from the previous year's campaign. On the whole, the Northwich electorate seemed to have indulged in less electoral 'rough play' during this second general election campaign. However, on one key occasion (undoubtedly a frightening one for those involved) a crowd descended on John Brunner's carriage as he made his way to an election meeting. The

Scene of the 1885 police charge on Witton Street.

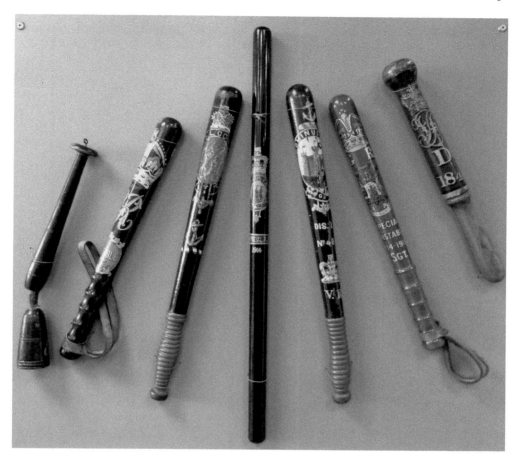

Victorian police truncheons. (From an Edinburgh Police Centre Museum collection; © Kim Traynor)

crowd tried to overturn the carriage with Brunner and his wife, Jane, still inside it. The carriage groom was assaulted, Brunner was pelted with refuse, and Jane Brunner was hit by an unidentified missile. The rest of the Northwich campaign passed by in peaceable fashion, though, and there was no repeat of the election night mayhem of the previous year. Brunner lost the 1886 election by 468 votes to Robert Verdin, who was returned to Westminster as a Liberal Unionist, and Northwich's second MP.

The 1886 election was the only Northwich election campaign that John Brunner ever lost. He returned the following year to stand as the Liberal candidate in the Northwich parliamentary by-election caused by the unexpected death of the sitting MP, Robert Verdin, as the result of a heart attack. The vote itself took place on 13 August 1887, and Brunner convincingly beat his main opponent, Lord Henry Grosvenor, the twenty-six-year-old son of the Duke of Westminster, who stood on behalf of the Conservative Party. The election campaign itself proved to be quite a tame affair. A gang of youths pelted Henry Grosvenor's carriage with large amounts of mud on election day (whether or not Grosvenor was inside the carriage is unclear), but there were no serious

outbreaks of disorder during the campaign. After winning in 1887, Sir John Brunner stayed on as Northwich's MP for the next twenty-three years, winning every election he stood in, until he voluntarily stepped down from the role in 1910.

Did you know?
John Brunner was never a dominant figure on the national political stage. Despite occasional dinners at No. 10 Downing Street, he remained a backbencher throughout his political career. Brunner did, however, become a Privy Councillor in 1906, and he was chairman of the National Liberal League from 1890 onwards. He was also master of all he surveyed on the Northwich political scene, and the leading liberal in Cheshire.

The once volatile Northwich male electorate seemed to be entirely at Brunner's command. There were a number of explanations for this local electoral dominance – being the town's major employer certainly helped. Brunner Mond acquired a reputation in many (but not all) quarters as being an enlightened employer, which gave Sir John some clear electoral advantages. There was much more to it than this, however. John Brunner was rather good at campaigning. He had a clear sense of humour, and in an age before television and radio, when public meetings dominated campaign schedules, he was quite adept at dealing with hecklers, both drunk and sober. He could turn aggressive, quite xenophobic comments and arguments on their head, and create laughter, as with his much-quoted riposte to being accused of being 'too foreign' during the 1885 Northwich Parliamentary election: 'My father was a Swiss, my mother was a Manx woman, I was born in Liverpool, my nurse was Welsh: Is that Cheshire enough for you?'

There were also other less obvious reasons for Brunner's success: the press are perhaps never totally neutral in any age, and from the mid-1880s onwards local newspapers, such as the *Northwich & Winsford Chronicle* and the *Northwich Guardian*, were very much on the side of Sir John Brunner. For example, during 1886, the *Chronicle* carried laudatory reports of Brunner's exotic tour around the world on the same page as it savagely criticised Robert Verdin's record and performance as Northwich's MP. Once Brunner had returned from his world tour, and was back campaigning in Northwich, this positive press 'spin' was clearly of some help.

Behind closed doors, largely beyond the notice of the Northwich electorate, Brunner also recruited some very talented individuals to help him with his political career. From the mid-1880s onwards, Brunner was sometimes criticised unmercifully for not being a local man. In 1891, Brunner and his wife moved to live in Wavertree, Liverpool, away from Winnington Hall in Northwich, which again left the MP open to criticism for not being locally based. To counter this, Brunner's appointment of Algernon Fletcher as his Northwich constituency political agent proved to be a very sound choice indeed, because Fletcher was a Northwich man through and through. Fletcher was born in Marston, Northwich, in 1845, and by 1871 he was lodging at a property in Castle and working as

Winnington Hall's Tudor wing – Brunner's home until 1891.

a solicitor in offices situated on Winnington Street. The division between Brunner's business and political interests was clearly a blurred one, as Algernon Fletcher joined the board of Brunner Mond (presumably dealing with legal matters) as well as acting as John Brunner's constituency political agent. The role of political agent and Brunner Mond board director certainly benefited Algernon Fletcher who, like other board members, eventually gravitated to Hartford, where he lived on Chester Road with his wife Harriet, daughter Winifred, and two servants, until his death in 1905.

Another key member of the political network that allowed John Brunner to dominate the Northwich political scene in the late Victorian period was Thomas Edward Ellis, born near Bala in North Wales, in 1849. Ellis was, if anything, even more important than Fletcher in the creation of the Brunner political machine in Northwich. The Welshman was the son of a tenant farmer who went on to study at Aberystwyth and Oxford, before John Brunner recruited him as his private secretary in 1890. Ellis had a meteoric rise in the Liberal Party, becoming MP for Merioneth in 1886, and the Liberal government's Chief Whip in 1894. During this whole period Brunner paid Ellis a salary as his private secretary (at a time when it was very unusual for one MP to have another MP as his private secretary). The Welshman was tipped to be a future prime minister by some, and he orchestrated all John Brunner's political moves and stratagems in Northwich. The Welshman, who was an early advocate of devolution for Wales, became very close to members of the Brunner family, and it was a shock to them all when he died in 1899, at the early age of forty, during a John Brunner-financed holiday in Cannes.

Thomas Ellis *c.* 1880. (© National Library of Wales)

With the help of skilled associates like Fletcher and Ellis, by 1910, the political scene in Northwich and around was entirely dominated by Sir John Brunner. The constituency, once known for its electoral volatility and rowdiness, seemed entirely at the disposal of the eminent industrialist, and it came as no surprise when his eldest son, John Fowler Leese Brunner, took over as Northwich's next MP in 1910. He stayed as Northwich's MP for eight years, until he was defeated in the 1918 'khaki' general election. Twenty-seven years later, in 1945, Felix Brunner stood unsuccessfully as Liberal candidate for the Northwich constituency. By this time, the Brunner name had been conspicuous in Northwich Parliamentary elections for sixty years. No single family is likely to achieve the same level of political dominance in the town again.

Did You Know?
The authors asked Mike Amesbury, MP for Weaver Vale (the modern successor to the Victorian constituency of Northwich), to read and comment upon the above chapter. Mike thought that the violence of the 1885 Northwich election was very unlikely to be repeated (though someone had once thrown a punch at him while he was on the campaign trail!). Instead, Mike believed that election threats and abuse were now largely an online issue. Mike also believed that John Brunner's public speaking skills were as valuable to an MP today as they were in the late nineteenth century.

3. The Cholmondeley Lords of Delamere

The Cholmondeleys are one of the oldest aristocratic families in Mid Cheshire, able to trace their ancestry back to the so-called 'bold lady of Cheshire', Mary Cholmondeley, who bought the vast Vale Royal Abbey estate, just south of Northwich, for £15,000 in 1615. Thereafter, the Cholmondeley family linked itself, via marriages, to many of the great families of Britain, and on 17 July 1821 Thomas Cholmondeley (born in 1767) was raised to the peerage as the 1st Baron Delamere of Vale Royal. For over 300 years, between 1615 and the 1940s, the Cholmondeleys had very close connections with the Northwich area, and the lords of Delamere proved to be some of the most colourful and controversial of Cheshire's aristocrats.

Mary Cholmondeley, the 'bold lady of Cheshire'.

Thomas
Cholmondeley, by
Henry Calvert.

By the time he became the 1st Baron Delamere, Thomas Cholmondeley was already a well-known figure in Cheshire. In 1792, he occupied the position of High Sheriff of Cheshire, and between 1796 and 1812 he was the Member of Parliament for Cheshire. In 1810, he married Elizabeth Williams-Wynn, the daughter of Sir Watkin Williams-Wynn, a powerful North Welsh baronet whose wife could trace her direct lineage back to Charles Greville, a former Hanoverian prime minister of Britain. Despite his service as an MP and a high sheriff, it still appears that money was the key factor in raising Thomas Cholmondeley to the peerage (at least according to the future 5th Baron Delamere). The 5th Baron claimed that the original title of 'Lord of Delamere' had been purchased for £5,000.

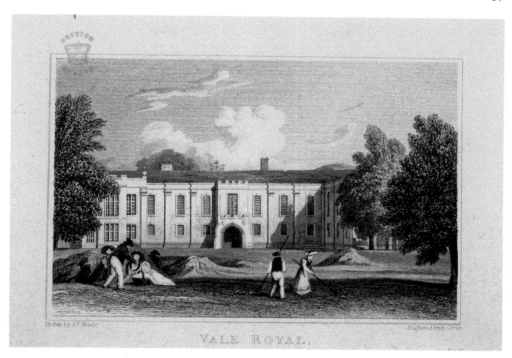

Illustration of Vale Royal Abbey, by J. Neale (1824).

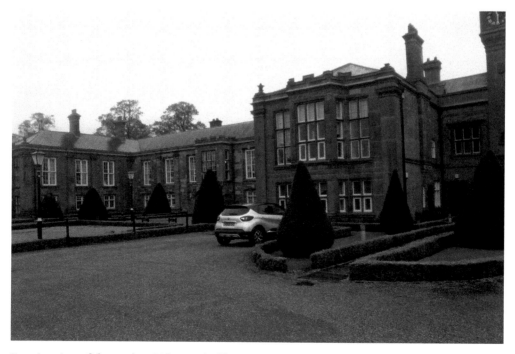

Exterior view of the modern Vale Royal Abbey.

Did You Know?
The purchase of honours and titles was nothing new in 1821. James I created the
title of baronet way back in the early 1600s in order to raise money. The 5th Baron
Delamere's chief criticism of his ancestor was that he paid more than he should
have done for the title – Thomas Cholmondeley paid £5,000 when, according to the
5th Baron, the going rate was about £1,200.

As the 1st Baron Delamere of Vale Royal, Thomas Cholmondeley achieved little of
distinction, though in 1836–37 he allowed the great engineer George Stephenson to
build part of the Grand Junction railway across his Vale Royal Abbey lands. In return
for allowing the railway to cross his property, Stephenson built Cholmondeley a rather
elaborate cattle tunnel, allowing Lord Delamere's cattle and farmers to cross safely from
one side of the rail track to the other. This tunnel, emblazoned with the Delamere coat of
arms at both sides, can still be seen today (though only from a distance).

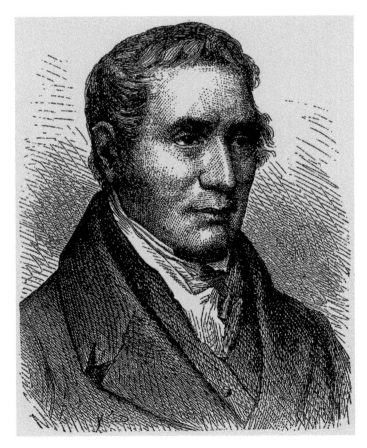

George Stephenson, by
Louis Figuier (1819–94).

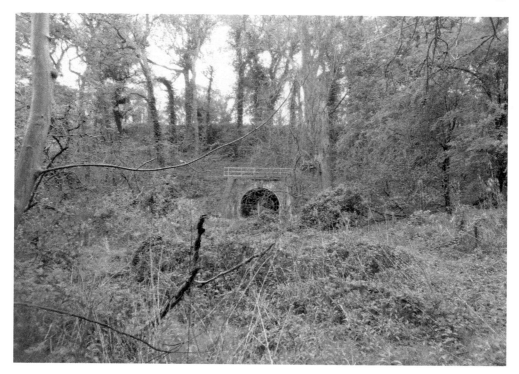

Stephenson's cattle tunnel.

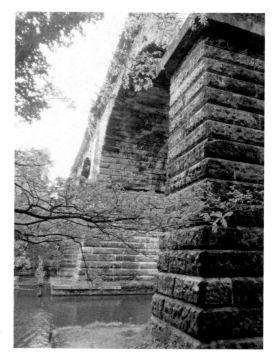

Vale Royal Viaduct, which brought the railways onto Delamere land.

The 2nd Baron Delamere, Hugh Cholmondeley, succeeded to the title in 1855, aged forty-four. Hugh was an MP representing the Welsh constituencies of Denbighshire and Montgomery during the 1840s, and he attended elaborate fancy dress balls at Buckingham Palace, hosted by the young Queen Victoria. He is perhaps best remembered for what he didn't do, rather than for any overwhelmingly positive achievements. In the early 1870s John Brunner was scouting around for a suitable site for his, and Ludwig Mond's, new alkali works. Vale Royal land, owned by Lord Delamere, was Brunner's preferred location for a new factory. However, Hugh Cholmondeley didn't like the idea of a chemical enterprise being situated on his land, and he turned down Brunner's proposal. Had the 2nd Baron Delamere accepted Brunner's ideas, the history of Northwich and Mid Cheshire might have been very different: Brunner Mond, and subsequently ICI, would have grown up on Vale Royal Abbey land, near Whitegate and Winsford, rather than at Winnington Hall, on the borders of Northwich township.

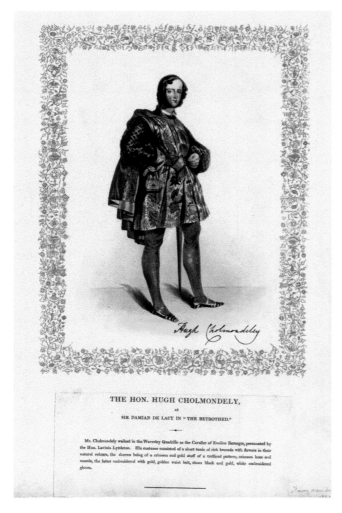

THE HON. HUGH CHOLMONDELY,

AS

SIR DAMIAN DE LACY IN "THE BETROTHED."

Mr. Cholmondely walked in the Waverley Quadrille as the Cavalier of Eveline Berenger, personated by the Hon. Lavinia Lyttleton. His costume consisted of a short tunic of rich brocade with flowers in their natural colours, the sleeves being of a crimson and gold stuff of a trelliced pattern, crimson hose and mantle, the latter embroidered with gold, golden waist belt, shoes black and gold, white embroidered gloves.

Hugh Cholmondeley at a Buckingham Palace fancy dress ball, 1842.

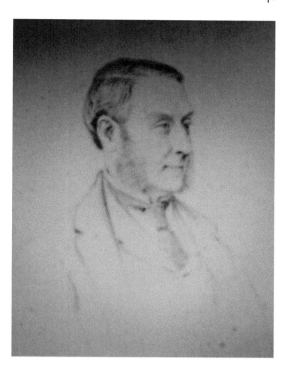

Hugh Cholmondeley pencil portrait, by
Frederick Sargent (*c.* 1860).

Hugh Cholmondeley, 2nd Lord of Delamere, was succeeded by his eldest son (also
Hugh) in 1887. The 3rd Baron Delamere has some claim to be considered the most
colourful and controversial of all the Cholmondeley lords of Delamere. Like his father,
this Hugh was born at Vale Royal Abbey, near Northwich. However, unlike his father, who
died on his Vale Royal Abbey estates, the 3rd Baron Delamere spent much of his life in
Africa, and died, aged sixty, in the British East African colony of Kenya. This particular
Hugh Cholmondeley's love affair with Africa began in 1891 when he left Northwich for
the first time on a lion-hunting safari to British Somaliland, in East Africa. After that,
he returned every year on safaris that were, to modern eyes, entirely reprehensible,
and involved the killing of large amounts of game. In 1894, he was mauled severely by
a lion, and walked with a limp for the rest of his life. This particular encounter with a
lion entered mythology, and in a BBC radio documentary broadcast in 1952, Delamere
was reported as wrestling single-handedly with the beast. In reality, however, after being
attacked by the lion, Delamere's Somali hunter, Abdullah Ashir, seems to have taken over
wrestling duties with the beast, giving the Northwich aristocrat time and space to seize
a rifle and shoot the unfortunate animal. Baron Delamere's African hunting exploits
were reported in newspapers across the country. On 2 October 1899, for example, the
Manchester Evening News covered the departure of the 'famous big game hunter' from his
Northwich estates, on what was his third African safari. The African expeditions launched
from Vale Royal Abbey were certainly massive in scale. In November 1896, for instance,
Delamere headed off from Northwich on a safari that (once he's landed in East Africa)
involved the gathering together of 200 camels, 200 rifles, and hundreds of armed escorts.

In 1897, Lord Delamere visited the colony of Kenya for the first time and was immediately smitten by the place. By 1906, he'd acquired a 50,000-acre Kenyan ranch at Soysambu, and a ninety-nine-year lease on a further 100,000 acres of Kenyan land. For the rest of his life, the 3rd Baron Delamere's time was split between Northwich and his massive estates in Kenya. His priority, however, was definitely the development of his farming and cattle interests in Kenya. Northwich and Vale Royal Abbey were very much secondary concerns, and the estate was leased out for long periods to wealthy families such as the Dempsters, and the American Rimmers, who lived lives of opulent ease at the abbey, and hosted numerous lavish parties in its sumptuous saloon.

Delamere's life, both in Kenya and at Vale Royal Abbey, was certainly eventful, and touched by considerable controversy. In 1907, he was charged with undertaking fraudulent land dealings in the colony (under the terms of Kenya's Indian penal code), though he was eventually cleared of all charges. The Northwich man proved to be a diligent and enthusiastic farmer, but is probably best remembered as being one of the founder members of the notorious Kenya 'Happy Valley' set. This group of affluent, white, British Kenyan landowners was centred in the town of Nyeri, to the east of the Aberdare

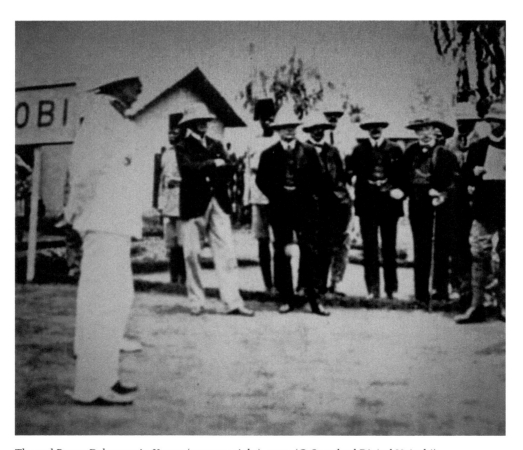

The 3rd Baron Delamere in Kenya (extreme right), 1909. (© Standard Digital Nairobi)

Vale Royal Abbey's saloon.

mountain range. Its members spent much of their time wife-swapping and drug-taking, and Lord Delamere indulged in bizarre activities such as riding his horse into the Norfolk Hotel in Nairobi and jumping over tables (undoubtedly an unsettling experience for both diners and staff). He also enjoyed chipping golf balls onto the roof of the Muthaiga Country Club, which was one of the Happy Valley set's favourite haunts. Delamere would then clamber onto the roof in order to retrieve the balls, much to the delight of those passing by.

The antics of the Happy Valley set ended in perhaps predictable disaster and scandal, when Lord Errol, who was one of the fraternity's most notorious rakes, was murdered in his car in a Nairobi suburb in 1941. Errol was having an affair with Diana Delves-Broughton, wife of 'Jock' Delves-Broughton. All three people were Happy Valley set regulars, and Jock was charged – and later acquitted – of Errol's murder, which remains unsolved to this day. The 3rd Baron Delamere played a peripheral role in the mystery, as Gwladys Beckett (his second wife) was a close friend of the Earl of Errol. Moreover, Delamere's eldest son, Thomas Pitt Hamilton Cholmondeley, ended up marrying the former Diana Delves-Broughton in 1955.

Away from the steamy affairs of the Happy Valley set, and back on his 7,000-acre Vale Royal Abbey estate, Hugh Cholmondeley, 3rd Baron Delamere, also hit the headlines and courted some controversy. On acceding to the Delamere title, Hugh had intended to pursue a military career, beginning as a lieutenant in the 3rd Battalion of the Cheshire Regiment. However, it was difficult to combine a full-time military career with being an African big-game hunter. Consequently, Hugh abandoned the Cheshire Regiment, though he did remain as a part-time member of the Cheshire Yeomanry. When he wasn't engaged on his extensive African safaris, Delamere seems to have spent his time hunting and shooting on the abbey estate. In September 1892, he was shooting duck from a boat on Petty Pool when he fell overboard and nearly drowned. Three years later, in 1895, the *West Cumberland Times* reported that Lord Delamere had been thrown from his horse while out riding with the North Cheshire Hunt, near Tarporley. The same paper reported that the injured man was subsequently being treated by Northwich and Tarporley doctors for severe spinal injuries, from which he made a slow but apparently complete recovery. When he was based in the Northwich area (rather than East Africa) the controversial aristocrat also tried to restrict public access to Vale Royal Abbey parkland. In May 1901, he began closing roads through the estate, which aroused the considerable hostility of Northwich Rural District Council, who instructed their clerk to gather legal evidence confirming the public ownership of these access routes. The dispute rumbled on into the following year, with Delamere trying to block public access to the section of New Park Road that ran between Whitegate and Cuddington. The district council resisted the move, and in retaliation Lord Delamere began to close other nearby footpaths and roads. The matter came to the attention of the local MP (Sir John Brunner), who sought and paid for legal advice out of his own pocket, as part of a campaign to maintain public rights of way through the Vale Royal estates. Rising tensions over this local issue may well have contributed to Lord Delamere's decision to depart again for his Kenyan lands. He left for Kenya as the arguments simmered, and he spent the next five years in the colony, only returning to the Northwich area, temporarily, at the end of 1907, in order to recover from a bout of ill health. The controversial 3rd Baron Delamere finally passed away in Kenya, in 1931, and his demise was reported in newspapers across the globe.

Initially at least, the new 4th Baron Delamere, Thomas Pitt Cholmondeley, seemed more interested in developing his estates at Vale Royal Abbey than farming in Kenya. He moved his family into Vale Royal Abbey in 1934, and when he wasn't in the Northwich area, the new Lord of Delamere spent much time motoring (often at high speed) throughout the UK. Indeed, Thomas Cholmondeley appeared in the British press on quite a regular basis, charged with one kind of motoring offence or another. In 1932, he was accused of dangerous driving in Reading, as the result of an incident in which his car smashed into a passenger-laden public tram. When the new Baron Delamere appeared in court he decided to conduct his own defence, which appears not to have been a wise move, as he was speedily found guilty and fined £6 for the offence (along with £3 10s in court costs). Moreover, his previous motoring offences, which included driving without due care and attention and speeding, were also read out publicly in the Reading court, and noted down and subsequently written about by the assembled members of the press. The publicity generated by this event didn't seem to radically alter Delamere's driving habits,

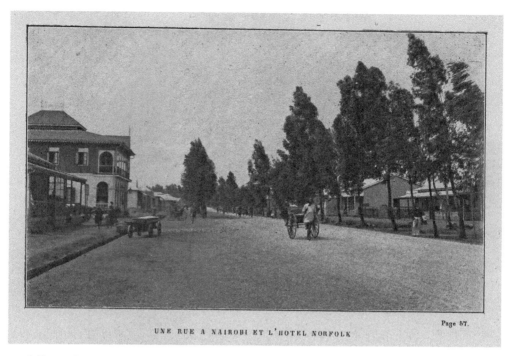

UNE RUE A NAIROBI ET L'HOTEL NORFOLK

Page 57.

Norfolk Hotel, Nairobi, by Jules Leclercq (1913).

Muthaiga Country Club, 1936. (© Matson Collection)

however, and in October 1935, he was again prosecuted for speeding (this time on the Perth–Dundee road, in a case heard at Perth Police Court).

During the Second World War, Thomas Cholmondeley served as a captain in the Welsh Guards, and Vale Royal Abbey itself was utilised as a sanatorium for convalescent soldiers. Once the war was over, Delamere made the decision that his future lay in developing the family lands in Kenya, rather than in Northwich, and Vale Royal Abbey was sold in 1947. With the sale of the Vale Royal estate, the last great landed property link between the Cholmondeleys and the Northwich area was at an end, though the Cheshire Delamere title remained. Publicity and controversy still followed the Delamere family, even after their departure from the Northwich area.

Did You Know?
The 4th Baron Delamere's 1955 marriage to the former Diana Delves-Broughton was certainly not a conventional one. During the 1960s and 1970s (when Diana discovered her bisexuality) husband and wife lived together in a rather celebrated ménage à trois with Diana's lover, Lady Patricia Fairweather.

Hugh Cholmondeley, Thomas Pitt Cholmondeley's eldest son, became the 5th Baron Delamere in 1979. By this time, the estates at Vale Royal Abbey were just a distant memory, and the main Delamere family focus was upon developing the Soysambu Ranch in Kenya. Hugh's heir (who would have been the 6th Baron Delamere) was Thomas Patrick Gilbert Cholmondeley. In 1997, Thomas was gored severely in the leg by a buffalo, and in 2005 he shot dead a ranger working for the Kenyan Wildlife Service. The circumstances of the ranger's death were decidedly murky. The Delamere heir pleaded self-defence and, amid a welter of contradictory evidence and statements, the Kenyan authorities declined to charge Thomas Patrick Cholmondeley with any offence whatsoever. The following year, however, Cholmondeley wasn't so lucky. In 2006, he shot dead an alleged poacher, and on this occasion, he was charged with murder, and spent over two years on remand in a Kenyan jail awaiting trial. At his eventual trial the heir to the vast Delamere estates in Kenya was found not guilty of murder, but guilty of manslaughter. He spent a further five months in prison, before being released in October 2009. The controversial heir to the Delamere title died of a heart attack in 2016, at the comparatively young age of forty-eight. His eldest son (another Hugh) born in 1998, became the heir-presumptive to the 200-year-old title of Baron of Delamere.

4. Policing and Crime in the Northwich Area, 1856–1945

The Cheshire Constabulary officially came into being on 11 April 1857 following the passing of the Police and County Borough Act by Parliament in June 1856. This particular Parliamentary Act created unified police forces in counties across the country. Cheshire was divided into nine police divisions, of which Northwich was one, and the county force was headed by one chief constable, who had fourteen sergeants and 164 constables under his control. This force had responsibility for much, though not all, of Cheshire. Chester, Wallasey, Birkenhead, Stockport and the boroughs of Congleton and Macclesfield had their own separate police structures, which continued in being for a considerable time after the passage of the 1856 Act. Rural areas just outside the township of Northwich often became part of separate police divisions. Oakmere, for example, formed part of the No. 3 Eddisbury division. The chief constable of the new county constabulary, Thomas Smith, was given a salary of £400 per annum, with an additional allowance of £60 for clothing and other expenses. By contrast, new constables in Northwich and elsewhere received just a boots allowance of 6*d* a week.

Did You Know?
The new Northwich police force, along with other divisions of the Cheshire Constabulary, was given a blue uniform with white Prince of Wales feathers as a badge. At some point after 1857, officers were also provided with cylindrical military-style shako hats (see below). This unusual form of police headwear was finally abolished by Sir Jack Beck, when he became Cheshire's chief constable in 1935.

The size of the new force in Northwich and the rest of the county was tiny, bearing little comparison to the large multifaceted Cheshire Constabulary of today. For twenty-one months, the Northwich division could not avail itself of the services of a single detective, as no detective branch existed in the county force. However, in January 1859, Thomas Smith appointed Constable Burgess as the county's first detective, on a salary of 25*s* per week. Burgess was given authority, directly under the chief constable, to operate throughout Northwich and the other eight divisions, and he was answerable to Smith alone, rather than to the commanders of the particular divisions. The new detective certainly had a difficult and rather solitary job, as Smith directed that other police officers should not acknowledge or salute Burgess in public. Detective Burgess was also told by the chief constable not to talk about his job, as 'a talkative detective is useless'.

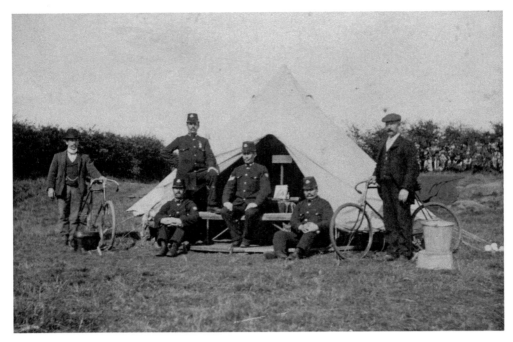

1902 police camp at Delamere, with constables wearing shako hats. (© Museum of Policing in Cheshire (MOPIC))

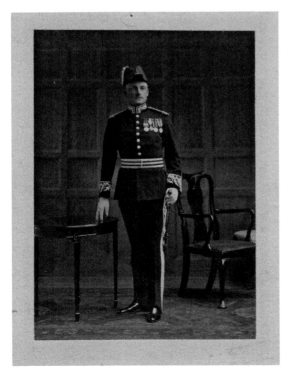

Jack Beck, Cheshire's chief constable from 1935 to 1946, in full dress uniform. (© MOPIC)

Jack Beck in civilian dress.
(© MOPIC)

The mid-Victorian constabulary in and around Northwich did the vast bulk of its work on foot. Only the Northwich divisional superintendent (along with the eight other divisional heads) was allowed transport, in the form of a £60 annual allowance for a horse and cart. Other police officers lower down the chain of command patrolled and conducted investigations on foot. Even though the Victorian era saw a great expansion of the railway network, the local constabulary were often reluctant to make use of the trains. Even at the end of the nineteenth century, it was not unheard of for a policeman to take a prisoner to Knutsford prison on foot, from anywhere within a 15-mile radius of the prison (including the township of Northwich and its environs). The twentieth century was, of course, the era of the motor car. Even so, it wasn't until 1934 that the Northwich police division acquired its first Alvis patrol vehicle. Another Alvis car was allocated for the use of Northwich's divisional superintendent.

Despite its limited transportation facilities, and its lack of detectives, the Northwich police force during Victorian times, and during the first part of the twentieth century, still had a wide array of functions and responsibilities. To begin with, the Northwich constabulary had a very close relationship with the Northwich workhouse, on London Road. Some police post-mortems were carried out using the workhouse hospital facilities. In addition, as part of their normal duties, the local police helped track down errant fathers who weren't contributing to the upkeep of their wives and families. The Northwich Workhouse Board of Guardians were always appreciative of police constables

who helped keep families together, and prevented wives and children from needing workhouse assistance (and thereby adding to the cost of the poor rate). In spring 1899, for instance, PC Millington was awarded the not inconsiderable sum of £2 by the board for apprehending one John Steele, who had deserted his family and left them in dire financial straits.

For at least a few years at the end of the nineteenth century, the Northwich police and the Northwich workhouse authorities also worked together in producing a 'ticketing' system, which allowed transient homeless people to stay overnight in one of the workhouse's so-called 'tramp' wards with police approval. The term 'tramp' was much overused in late Victorian and Edwardian England, and could be used to refer to anyone unlucky enough to lose their homes and occupations as a result of economic depression, illness and other factors. The ticketing system seems to have involved the homeless person visiting Northwich police station and securing written authority, which then allowed them to move on to London Road and gain admission to the workhouse for the night. By 1903, this system had ended, though not everyone was aware of the fact. During June 1903, Michael Smith and Horace Martin (two unemployed ex-railway workers) hoped to use the ticketing system to sleep overnight at the workhouse, while walking between Crewe and Manchester. However, the Northwich police were no longer able to issue a 'ticket' and the workhouse was closed when they tried to gain admittance. Instead, the two men spent the night sleeping in the brick kilns of Renshaw's brickworks in Lostock Gralam, with their feet resting in the kiln fire grates. Here they were arrested on the following morning by PC Davies and charged with the offence of vagrancy. Under the terms of the 1824 Vagrancy Act, sleeping rough and begging were made criminal offences, punishable by up to one month in prison. Brick kilns and fire grates were obviously dangerous places to sleep, but the men did no damage to the brickworks, and were previously of good character. Despite this, the two men were found guilty of the offence of vagrancy at Northwich Police Court and sentenced to seven days' hard labour in prison.

During the Victorian and Edwardian period, the Northwich police spent much of their time enforcing the Vagrancy Act, and its subsequent amendments. In 1903 alone, the local constabulary enforced the Vagrancy Act on numerous occasions (in addition to the already mentioned case of Smith and Martin). John Leonard, for example, was arrested for begging in the Bull Ring on one Sunday early in the year. He was a local man who'd fallen on hard times after suffering from a badly broken leg. The injury was sufficiently severe for the vicar of Little Leigh to support a recommendation that Leonard be housed in sheltered accommodation in Manchester. Even so, John Leonard still had to beg for money, for which offence he was arrested by PC Griffiths, who also suspected that Leonard had stolen a sovereign coin on the previous Saturday night. It's unclear whether John Leonard was actually found guilty of the theft of the sovereign when he appeared at Northwich Police Court, but he was certainly guilty of the offence of begging, for which he was sentenced to fourteen days' hard labour in prison.

In the Victorian and Edwardian period (as in more recent times) much disorderly behaviour and petty crime was fuelled by drunkenness. The year 1903 again furnishes some clear examples of the Northwich constabulary having to cope with the impact of drunkenness and alcoholism. Annie Hall, from Rochdale, for instance, was arrested late

one night in early 1903 for hurling abuse at a variety of passers-by on Applemarket Street, in the centre of town. She was actually arrested by PC Bolsover on the steps of the Fox Inn, where she was described as being in a 'very filthy condition'. The severely drunk Annie had, in fact, been living rough for the previous fortnight, tramping the streets of north-western England, and she was clearly in need of some shelter. The woman was clearly a vagrant, under the terms of the 1824 Act, and drunk and disorderly. Despite her intoxication, however, she made it very clear to PC Bolsover that she welcomed a night in the Northwich police cells. When Annie was fined 10s for her behaviour at a subsequent hearing of the Northwich Police Court, she was obviously unable to pay the fine. Instead, she seems to have accepted the alternative punishment of seven days in prison with some alacrity – at least she had a (prison) roof over her head and a bed for the next week.

The need for alcohol also seems to have fuelled other crimes reported by the local press during 1903. Early in the year, two Northwich police sergeants, Ennion and Carter, were leading an investigation into a jewellery theft in which a silver watch, watch guard and a Boer War medal, with a total value of £2, were stolen from a woman named Anne Price. The actual theft was carried out by a fifteen-year-old Barnton girl called Florence Smith, who passed on the stolen goods to her aunt, Susannah Bell, who ended up pawning the items for a meagre 6s 6d. The adolescent Florence's motives for the theft are unclear, but she was clearly very much under the influence of her older aunt, Susannah, who was apparently an habitual drunkard who needed whatever money she could obtain in order to sustain her addiction to alcohol. Both females were eventually found guilty of theft. Florence was sent to prison for fourteen days, and her aunt, Susannah, was gaoled for the longer term of one month.

The Northwich Constabulary of the late nineteenth and early twentieth centuries was engaged in far more than just liaison work with the local workhouse and the investigation of small-scale crimes and misdemeanours. On occasions, the division's activities attracted national attention. In 1898, for instance, Northwich police were tested by a rather bizarre and baffling crime involving Gustav Jarmay, a brilliant Hungarian chemist who was appointed a director of Brunner Mond in 1888. Jarmay and his wife, Charlotte, lived in some splendour at Hartford Lodge (now called Whitehall) on School Lane in Hartford. In his private life, Jarmay pursued the activities of the quintessential English country gentleman. He rented land in Wales on which he could shoot game birds and catch fish, and he also rode with the Cheshire Hunt and attended point-to-point race meetings. He owned a fine stable of horses and, in 1898, five of his prized hunters were intentionally poisoned with arsenic. All five horses died, and the local police were called in to investigate this strange crime, which could have come straight out of the pages of a Conan Doyle Sherlock Holmes novel. Newspapers across the country carried details about the incident, and police offered a reward of £50 for information leading to the arrest and conviction of those involved (a sizeable sum equivalent to roughly £6,500 today). Despite the offer of a large reward, however, the motive for the poisoning was never discovered, and the crime remained unsolved.

The 1890s also saw the Northwich division police involved in the investigation of a particularly gruesome murder. The murder itself took place in spring 1893, at a small lodging house and provisions shop in Church Street, Northwich, run by a sixty-year-old

Gustav Jarmay (back row, fourth from right) in 1913. (© Catalyst, Widnes)

South-facing view of Jarmay's Hartford Lodge home (now Whitehall).

woman named Margaret Deakin. The house itself seems to have been crowded with lodgers. A woman called Mrs Thomas lived at the rear of the premises, and another lodger, Elizabeth Heald, seems to have spent at least some nights sleeping on a mattress in the same room as Mrs Deakin and her husband (who worked as a labourer at Brunner Mond). Mrs Deakin and the younger Elizabeth Heald seem to have been arguing increasingly over a period of some weeks. On one particular evening, Mr Deakin returned to find the house front door locked. He forced an entry and discovered the dead body of Elizabeth Heald in the bedroom formerly occupied by both the Deakins and Elizabeth. Heald's throat had been cut with some savagery, and his wife, Margaret, was nowhere to be seen. Police immediately began a hunt for Mrs Deakin, who was arrested in Deansgate, Manchester, on the following day. Solving the crime seems to have required little actual detective work, though Mrs Deakin did place a knife in Heald's left hand in an effort to make the crime look like suicide. When Mrs Deakin was picked up in Manchester, a female police searcher discovered a blood-stained door key and skirt in the fugitive's possession. Police Sergeant Hunt returned to Northwich with Margaret Deakin, who was charged with murder. Mrs Deakin always denied the charge, though she was later found guilty, at her trial at Chester Assizes, and sentenced to be hanged. The motives for her crime will forever remain unclear, though the jury at her trial, probably because of her age, did recommend clemency. In January 1894, (a matter of days before she was due to be hanged at Knutsford prison) Margaret Deakin's sentence was commuted to one of life imprisonment.

Murder and serious crime in the Northwich area was, thankfully, not a regular occurrence. Policing the Northwich area during the two world wars of the twentieth century presented the local constabulary with far greater challenges. To begin with, even with the country at war from 1914 to 1918 and 1939 to 1945 police in Northwich and elsewhere still had to continue with their normal activities – crimes had to be investigated and the king's peace still needed to be maintained. This was even more difficult in wartime, when seasoned police officers who were reservists departed to join either the army, navy or air force. As far back as the Anglo-Boer War of 1899–1902, enthusiastic Northwich policemen like PC Harry Wibberley had left the town to serve in their country's wars, and many more followed suit during the early days of both the First and Second World Wars. The police officers left behind were saddled with some new wartime duties to perform, in addition to their normal peacetime functions. During the First World War, Northwich police proved to be particularly adept at identifying and then arresting soldiers who were absent without leave (AWOL) from their regiments. In October 1914, the keen-eyed PC Platt arrested Peter Rawlinson on Manchester Road, Lostock Gralam, for being a suspected deserter from his regiment. Platt's suspicions were aroused by the fact that Rawlinson was wearing a civilian flat cap as part of his army uniform. As it turned out, Rawlinson was indeed AWOL from the King's Liverpool Regiment, and he was also in possession of a false leave pass. The unfortunate soldier, who was still in training, was kept in custody until a military escort could be found to return him to his regiment, and PC Platt was awarded 5s by Northwich Police Court for spotting and detaining Rawlinson.

During this same early part of the First World War, when volunteers were being trained in England, prior to being deployed to the Western Front, William Cross, a dentist from Chester Road, Northwich, was also detained by the local police. Cross had gone AWOL from his training in Great Crosby, in order to return home and carry out some lucrative fee-paying tooth extractions. He was arrested by a Northwich policeman as he emerged from his home on a bicycle, and he was returned to his regiment under military escort. The constable involved in the arrest was again awarded 5s by the Northwich Police Court. Local police were spared the necessity of keeping order in bombed-out towns and cities, though guidelines were issued on how to deal with downed Zeppelins, and there were small-scale attacks on nearby areas of Warrington in 1918. During the Second World War, however, maintaining order in blitzed north-western cities became an important function for members of the Cheshire Constabulary. When Liverpool was blitzed for six consecutive nights during May 1941, police officers based in Northwich left every night to help maintain order in the devastated city. On one notable occasion, in October 1941, local police played the same role of helping to maintain order in Northwich itself when a stray German parachute mine damaged houses and industrial property in the town following a Nazi bombing raid on nearby Manchester and Altrincham.

Archibald Horden in civilian dress. (© Cheshire Constabulary)

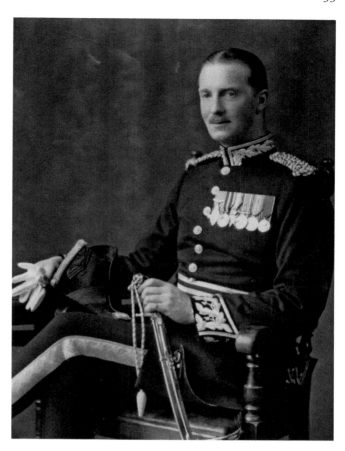

Horden in full dress uniform.
(© MOPIC)

By the end of the Second World War, in 1945, the Northwich division police force had played a major role in the overall development of the Cheshire Constabulary. Its officers had participated in some significant investigations, and at least a few of the policemen linked to the Northwich division achieved some national recognition. Detective Inspector Kingman, for example, played a leading role in the capture of a four-man IRA gang from Wallasey and Liverpool, who were sabotaging railway signalling and communications in Bromborough on the Wirral during 1921. He was officially commended for his actions and, in 1926, was promoted to become the first detective superintendent in Cheshire, before finally taking charge of the Northwich division in 1929.

Perhaps the policeman with the most significant links to the area of Northwich and around was Archibald Horden, chief constable of Cheshire in 1934–35. Horden had an impressive background, with army experience that stretched back to 1909, including service in Ireland and West Africa. During the First World War, he joined the Royal Flying Corps as a pilot, and was awarded the Air Force Cross. After the war, he began a glittering career in the police force, and was chief constable of the East Riding of Yorkshire between 1926 and 1934. In 1924 he was awarded a CBE, and later, in 1946, he received a knighthood.

Did You Know?
Archibald Horden certainly led a varied life. In addition to his army and air force service, he had also been an MI5 spy, and during the Second World War he attended a meeting in a Manchester building that received a direct hit from a German bomb. Horden's chauffeur was killed, along with other police officers. Horden himself, however, emerged unscathed, suffering from little more than shock and some minor cuts and bruises.

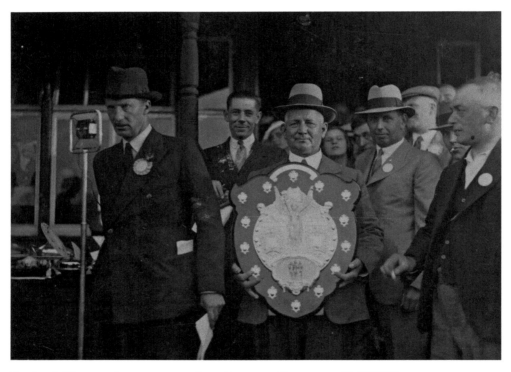

Horden (left) presenting a sports trophy to Broxton police, *c.* 1934. (© MOPIC)

Although he was only the head of the Cheshire force for one year (before moving on to become chief constable of Lancashire) many of his most significant plans and achievements were connected to the Northwich area. To begin with, he actually lived in Hartford, and set up a police processing department in an outbuilding of his home. He also planned to move the headquarters of the county constabulary from Chester to a huge 32-acre 'police colony' at Sandiway, on the Chester–Manchester road, and £6,000 was allocated for the purchase of land required for this new 'colony'. Although nothing came of the Sandiway police colony plans, the idea of a new county police headquarters building based in the vicinity of Northwich did remain alive for quite some time.

In July 1945, the Standing Joint Committee (which was the police authority for Cheshire) allocated £9,200 for the purchase of Vale Royal Abbey, which was to be converted into a new Cheshire Constabulary headquarters, surrounded by forty-three new police houses. This idea didn't survive for long, however, in the era of post-war austerity, and plans for the conversion of the property were dropped in December 1946. Ultimately, of course, in the twenty-first century, it was in Winsford rather than Northwich that the new county police headquarters were constructed.

During his time as Cheshire's chief constable, Horden's greatest success probably came with his approach to solving the Northwich safe robbery case of March 1935. The robbery itself was not a particularly spectacular or successful one. Three thieves named William Parkinson, Violet Boothby (his partner) and John Melia, stole a safe from a Northwich bookmaker's during the night of 8 March 1935. The considerable sum of £7,500 was inside the safe, largely made up of six large denomination £1,000 notes issued by the Bank of England, together with some £50 and £100 notes and bags of silver and copper coins. The large denomination £1,000 notes proved to be easy to trace, and the robbers were behind bars within a few months. Parkinson received a hefty ten years, and Boothby and Melia each received five years in prison. By the end of the investigation, all but £200 of the stolen money had been recovered. However, the way in which Archibald Horden sought to bring the Northwich robbers to justice provided a template for the investigation

£1,000 notes were issued between 1725/45 and 1945. (© Bank of England)

of serious crimes that influenced Cheshire and national policing methods for decades to come. To begin with, the Express Message System (pioneered by Horden and used for the first time in tracking down the Northwich safe robbers) was activated to provide rapid details of the crime to 147 police forces throughout the UK. Details were also given to major newspapers in Manchester and London using the same new system. The resultant publicity played a major part in helping to track down the perpetrators to their hideaway at Llanferres, near Mold in Wales. In addition, Horden made sure that the police had access to the best scientific advice available during the course of their investigations. Professor Tryhorn, Head of Chemistry at Hull University, was brought in to examine jemmy marks at the burgled house in Northwich, and he later matched these marks with a jemmy found in the possession of the robbers. Dr Cooke, from Wigan, who was a national expert on dusts, was called in to examine the stolen safe, when it was recovered in Wales, along with other relevant items. Neville Strange, a consulting engineer from Manchester, was also asked to examine the car used by the robbers to take the stolen safe from Northwich to Wales.

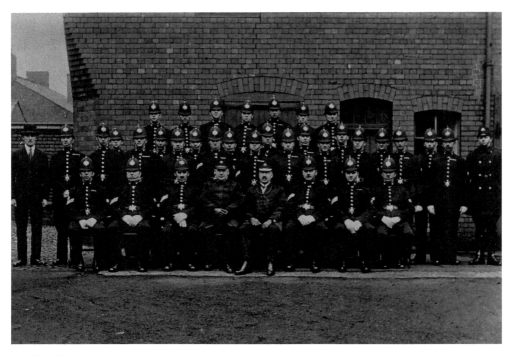

Northwich Division, c. 1935. (© MOPIC)

5. Poverty and the Northwich Workhouse

The 1820s and the 1830s proved to be difficult and unsettling times for the people of Britain. Large numbers of soldiers and sailors re-entered the labour market after the end of the Napoleonic Wars, and they did so at a time when population levels were growing, and industry and society was changing rapidly as a result of the Industrial Revolution. Economic downturns generated high unemployment in parts of Cheshire, and elsewhere in the country, which meant that huge numbers of people were unable to provide even the basic necessities of life for themselves, and for their families. These problems of hunger, unemployment and poverty were exacerbated by social tensions, as people in the burgeoning towns and cities, led by groups such as the Chartists, sought a fairer and more equitable electoral and political system. It was within this overall social and political context that national government attempted to sweep away the traditional method of 'outdoor relief' for the poor (which had operated since Elizabethan times) via the passage of the radical Poor Law Amendment Act of 1834. This 'outdoor relief', which operated at parish level in Northwich and all its surrounding parishes and townships (as it did in the rest of the country) provided some relief from poverty via handouts of food, money and clothing, to those most in need. All this was intended to end in 1834, with a new system that involved the amalgamation of parishes into Poor Law Unions, who would henceforth be given the responsibility of dealing with the poor within their particular areas. However, the really key change was that these Poor Law Unions were meant to tackle the problem of poor relief and poverty, principally, via the creation of workhouses. These workhouses would provide indoor relief, behind closed doors, and the age-old practice of outdoor relief was to be cut. The desire to save money was one of the principal motivations behind the creation of the new system, which lasted until workhouses were abolished on 1 April 1930.

The Northwich Poor Law Union, created in response to the 1834 Act, was a large organisation covering most of Mid Cheshire. When it came into being on 20 October 1836, the union contained sixty-one constituent parishes, ranging from Goostrey and Allostock in the east, to Hartford and Weaverham in the west. At its core were the townships of Northwich and Witton-cum-Twambrook, which were already recorded as having populations of 1,481 and 2,912 respectively in the census of 1831. The main focus of union attention was the Northwich Workhouse, which was constructed on London Road, Leftwich, between 1837 and 1839. The workhouse, once completed, was to be overseen by a fifty-nine-strong Board of Guardians, drawn from the constituent parishes and townships of the Northwich Poor Law Union. The building itself was designed by the Nantwich-based architect George Latham, and largely followed the model 'square' template advocated by the Poor Law Commissioners of the time. Only the two-storey entrance block now survives, which originally accommodated receiving wards for inmates,

The surviving front block and entrance to Northwich Workhouse.

Rear view of the workhouse front block.

a porter's room, and working facilities for the master of the institution. In addition, an L-shaped extension to the southern end of the entrance block was built in 1892, which was turned into a new Guardians' boardroom. However, the original building also contained other three-storey accommodation blocks, situated behind the entrance block, which gave the whole workhouse a panopticon, prison-like style, where workhouse staff could easily observe inmates in corridors, wards and exercise yards at all times of the day or night. The prison-like design of the original building was entirely intentional because Northwich Workhouse (like other workhouses) was built in pursuance of the principal of 'less eligibility' – life was meant to be grim in the workhouse, and the architecture reflected this fact. The supporters of the 1834 Poor Law Act believed that conditions in the Northwich Workhouse – and every other workhouse – had to be tougher than those experienced by the poorest individual or family living outside the institution. Only in this way (so the argument went) could the financial costs of providing poor relief be kept within reasonable limits. The principle of less eligibility was designed to try and ensure that those in need would resort to almost any measures in order to avoid the indignity of being admitted to the workhouse.

One of the obvious indignities suffered by those admitted into Northwich Workhouse was segregation. Men and women were mostly kept apart, with men sleeping in the accommodation block to the north, well away from the women who were in the southern accommodation block. Children were also kept apart from their parents, and physical exercise was conducted in segregated yards. Uniforms were issued on admittance to the

Rear of the 1892 extension.

Section of Victorian floor tiling in the entrance to the 1892 extension. (© R. Lamb)

institution, and to complete the prison-like image of the workhouse compulsory work activities were also undertaken. For women, a typical task might involve the unpicking of rope fibre in order to make oakum (used to provide waterproof sealings for ships) while the men might be rock-breaking or grinding bones into fertilizer. Food was also basic in the workhouse, though it did improve, in Northwich and elsewhere, during the course of the nineteenth century. Various model dietaries were planned by the Poor Law Commission, which provided workhouse inmates with between 137 and 182 ounces of food a week, plus soup and gruel.

Even though life in Northwich Workhouse was tough, hundreds of men, women and children still had little choice but to enter the institution in order to provide themselves with the basic necessities of life. Census returns, together with press reports of Board of Guardian meetings, do provide us with valuable information regarding inmate numbers, particularly for the period between the 1880s and 1914. Inmate numbers could certainly fluctuate in response to both local and national economic policies and conditions. In the 1881 census, only 110 residents and six staff were recorded as being present in the workhouse. By the late 1890s, this figure had gone up considerably, with 197 residents reported as being present during early summer 1898. During the early years of the twentieth century, there was a modest reduction in inmate numbers. In late April 1903, there were 177 recorded inmates at the workhouse, and by November 1914 this figure had dropped to 157 inmates.

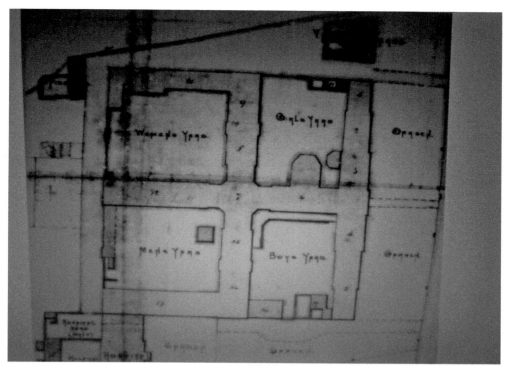

The 1860 Northwich Workhouse plan, showing segregated layout of buildings (now demolished).
(© R. Lamb)

Dietary plans for workhouse inmates, published 1866.

Such statistics do, however, only provide a partial glimpse of life within the Red House (so called because of the red colour of the brick used in the workhouse construction). For a start, not everyone within the complex of buildings at the Red House was classified as an inmate. Workhouse additions such as the fever hospital, built in 1850, were occupied by patients rather than inmates. Secondly, though total workhouse numbers could remain reasonably static between one month and another, the makeup of the workhouse population was changing constantly, on a daily basis. The majority of those within the Northwich workhouse were there, perhaps not surprisingly, on a temporary basis. Seasonal workers came and went according to the time of the year, but the most temporary of the Northwich Workhouse inmates were the vagrants, or so-called 'tramps,' who were without homes, money or jobs, and often had no real connection to Northwich. These unfortunate people were mostly just drifting through the town, in search of a night's shelter and food, before they moved on to another location. Even so, these vagrants were seen as a threat by many local people. During June 1903, the *Winsford & Middlewich Chronicle* ran a story entitled 'Tramp infested Northwich' about the events of one particular Saturday night in June, when fifty-two vagrants sought admittance to Northwich Workhouse. Fourteen of these homeless people came from the Manchester area, with others coming from all over Cheshire and Lancashire. Admitting such a large number of homeless people on one night would undoubtedly have put a large strain on

Northwich Workhouse master's room.

workhouse resources, and it was no surprise, therefore, when Ernest Pritchard (perhaps Northwich Workhouse's best-known master) commented to the paper that 'tramps were becoming an intolerable nuisance'. Though Pritchard might not have liked dealing with the vagrant population of the North West, he continued to accommodate them within the workhouse. During November 1914, the *Runcorn Guardian* reported that eighty-two vagrants had been admitted to Northwich Workhouse under Mr Pritchard's aegis, though this was far fewer than the 130 vagrants given some assistance during the same period of 1913.

Did You Know?
Elderly people, who were unable to count on financial support from family members, also made up a considerable proportion of the Northwich Workhouse population. In the 1881 census, over 34 per cent of the inmates (thirty-eight out of 110) were aged sixty-five or over. More surprisingly, in the same census over 18 per cent of the inmates were former domestic, farm or general servants. Clearly, many servant jobs were so poorly paid that they were little more than a passport to poverty and the workhouse in later life.

Children, and those with physical and mental disabilities, could (like the elderly) end up as long-term inmates of Northwich Workhouse. In the 1881 census, 28 per cent of workhouse inmates were aged eighteen or under (thirty-one out of 110). In May 1903, Ernest Pritchard told the assembled Board of Guardians that Northwich Workhouse was responsible for the welfare of seventy children, and in both 1913 and 1914 there were over forty child inmates at the institution. Not all of these children were ensconced within the Red House, however. As Pritchard explained to the Guardians in their May 1903 meeting, thirty-eight workhouse children were living in various local homes, and six boys had been sent to institutions well away from the Northwich area. These six boys were of particular concern to Pritchard, who believed they had 'bad and vicious parents and relatives and [were] those from foul surroundings'. Ultimately, Pritchard and the Guardians were interested in sending these troubled youngsters to houses where they could be prepared for emigration to Canada. The Northwich Workhouse promised to contribute 5s a week towards the maintenance of each boy, until such time as they were ready to be sent to Canada. After that, the Northwich authorities also agreed to pay the actual costs of passage.

Northwich Workhouse schoolroom.

Did you know?
Between the late 1860s and 1948, over 100,000 children were sent to Canada from the UK to be used as indentured farmworkers and domestics. The monitoring of these children was often neglected, and they were sometimes grossly overworked. The children were sent from a variety of organisations, including workhouses, Barnardo's and the Salvation Army.

While a few boys were earmarked for emigration, others were targeted for entry to the armed forces. There is evidence that at least in some instances, these Northwich Workhouse boys forged successful careers for themselves in either the army or navy. John Smith, for example, was brought up at the Red House during the 1890s and joined the Royal Navy as an apprentice deep-sea diver. Smith seemed to look back on his time at the workhouse with some affection, and corresponded with Ernest Pritchard and his wife, Mary, during 1914 when he was an able seaman aboard HMS *Blenheim*, based in Malta.

While children could move on from the workhouse once they'd attained adulthood, it was more difficult for inmates with physical and mental disabilities to establish an

independent life outside the Red House. In 1861, the Poor Law Board published the names of all adult paupers who had been resident in a workhouse, continuously, for five years or more. The Northwich Workhouse possessed thirteen such people, including one blind inmate and an epileptic. In addition, the inmate Richard Woodhouse had, by 1861, been a resident of the Northwich Workhouse for twenty-two years, and was described as suffering from 'idiocy'. Seven of the other twelve long-term residents identified in 1861 were described as suffering from 'weak minds', and in the 1881 census six of Northwich's inmates were classified as being 'imbeciles'. The brief and rather brutal language used to describe such people does illustrate the lack of understanding and knowledge of such issues in Victorian times.

The 1861 figures for Northwich contain some really tragic family details. Sarah, Jane and Mary Holland were all from the same family, and all had been inmates of the Northwich Workhouse for at least six years. The three women, who had once lived together at Old Hall Yard, off Witton Street, in central Northwich, were all described as being of 'weak mind'. Sarah, the youngest of the Holland women, was still a resident of the Northwich Workhouse twenty years later, in 1881, having spent all of her adult life in the institution. It's unlikely that all three women were suffering from 'weak minds' when they entered the workhouse. Instead, the Holland women probably experienced some kind of economic calamity connected to the death of their father, Thomas Holland, in 1851. Economic necessity almost certainly drove the women into the workhouse. Subsequently, though, their mental health may well have been damaged by the trauma of spending so many years in such a place.

Outdoor Relief

Many of the Poor Law Unions of northern England were utterly opposed to the curtailment of outdoor relief in the 1834 Poor Law Act. Even so, the Poor Law Commission and the Poor Law Board issued prohibitory orders that banned the provision of outdoor relief to the able-bodied between 1840 and 1866, and these regulations remained in place until 1871. Despite these prohibitions, many local Poor Law Unions still found ways of assisting the poor in the community, away from the workhouse. As far as the Northwich Union Workhouse is concerned, there is evidence of considerable outdoor relief taking place between the late 1890s and 1914, when Ernest Pritchard was in charge of the institution. Pritchard announced the figures for both indoor and outdoor relief at Board of Guardians meetings, which were reported assiduously by a range of local newspapers. In the week preceding the Guardians' meeting of April 1899, Pritchard announced that a total of 859 people had received outdoor relief from the workhouse, which was a drop of 101 from the numbers given outdoor relief during the same period of 1898. During each of the years 1902 and 1903, over 930 people were given outdoor aid, though this figure had declined to 677 people by 1913, and 717 in November 1914. The outdoor relief figures announced by Pritchard certainly highlight the significance of this method of poor relief in the Northwich Union area. Far more local people were likely to be the recipients of outdoor relief than indoor (workhouse) relief. In 1872, a report of the Local Government Board suggested that nationally, there were roughly five outdoor paupers receiving aid

for every one pauper ensconced within a workhouse. This national ratio for 1872 seems roughly true for the Northwich area between the late 1890s and 1914, when there were approximately four to five people receiving outdoor aid for every one person who was an inmate at the London Road workhouse. Of course, outdoor relief was much cheaper than indoor workhouse relief. In fact, assisting the poor outside, in the community, probably cost half as much as maintaining the poor inside, within a workhouse. Outdoor relief levels in Northwich, and nationally, were also very low. For example, during one particular week in 1899, Pritchard's Board of Guardians divided just over £34 in outdoor assistance between 859 successful claimants. The individual amounts paid out (though varied) were obviously very small indeed, and probably insufficient for the recipient to survive upon, unless he or she had other means of support.

6. Health, Smells and Infectious Diseases

For much of the period between 1850 and 1950, the Northwich area was plainly a very unhealthy place to live. Conditions for salt workers in the area were often primitive, and working hours were long and arduous. From the 1880s onwards, the Brunner Mond alkali works in Winnington was Northwich's biggest employer, and conditions in the Winnington Works became the subject of repeated articles in national newspapers such as the *Labour Herald*. Indeed, the famous socialist firebrand Tom Mann worked undercover in Northwich for a short time during 1888, under the pseudonym of Joe Miller, in order to publicise the long hours and dangers to workers health present at the Brunner Mond Winnington Works. In reality though, these dangers were somewhat exaggerated (the death rate in Winnington was about eight per thousand in 1889).

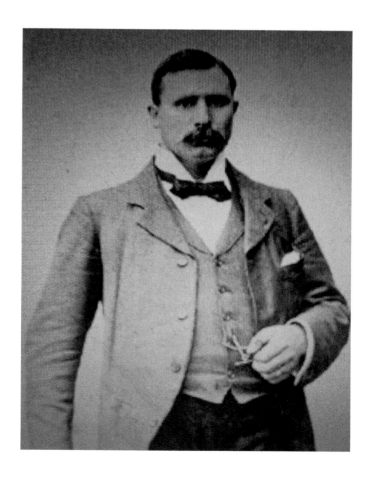

Tom Mann, 1856–1941.

Workplace dangers to health paled into insignificance when compared to the far greater risks caused by the many contagious diseases present in the Northwich area during this period. Typhoid, diphtheria, smallpox, scarlet fever, measles and tuberculosis (TB) all made their presence felt in and around Northwich, and in particular years, such as 1896, there were epidemics of such contagious diseases. In addition to these contagions, there were the 'normal' killers such as the cancers, heart problems and ruptures – not to mention influenza and pneumonia – which gave the Northwich district an annual death rate of just under sixteen per thousand in the late 1890s. The death rate for babies less than twelve months old was much higher than this – Dr Garstang recorded in his Medical Officer of Health's 1898 'Annual Report for the Northwich Rural District Council' that there were 154 deaths of babies less than a year old, for every 1,000 births. Typhoid, or enteric fever as it was sometimes known, was a particularly contagious disease, often spread via human faeces in contaminated water, and made regular appearances in the Northwich area during this period. During 1874, the fever wards of the Northwich Workhouse were used to accommodate typhoid cases from Leftwich. Nearly twenty-five years later, in 1898, typhoid was still a serious problem in the Northwich area. In February 1898, a woman contracted the disease in Moulton. As was common at the time, her excreta was saved in a bucket for later examination. Unfortunately, the bucket was left in a public yard, and the foetid mess was played with by three children, who all contracted typhoid during March 1898.

Watercolour of the arm of a child who is exhibiting typhoid, 1890. (© Wellcome Images)

Abb. 5 (Siehe Seite 74)

Young man with a fatal case of typhoid, 1840. (© Wellcome Images)

Hartford was also a centre of typhoid outbreaks, with four cases recorded between July and October 1898. The village of Hartford was very much the place to be during the late nineteenth century. Brunner Mond, for example, encouraged its directors and up-and-coming managers to relocate to Hartford, away from the limepit vapours and chemical smells of central Northwich and Winnington. Unfortunately, Hartford had its own serious sanitation problems. During 1898, diarrhoea was widespread in the village, and Dr Garstang had many complaints about the foul smells emanating from various locations in the area. In part, these foul smells were due to the absence of working stench traps in the village. These stench traps were water seals attached to pails and sewers, which prevented the upward flow of foul-smelling gases. Regrettably, Hartford was also suffering from a catastrophic failure in the local human waste matter collection service. In an era before modern flushing WC systems, most people in the Northwich area deposited their human waste in pails or buckets, which were then collected by individuals and companies contracted to the local authorities. In Hartford, however, many pails hadn't been collected for over two years, which would certainly have contributed to the malodorous and insanitary conditions in the village.

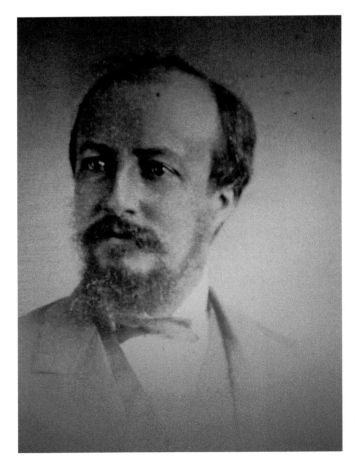

Edward Milner, resident of Hartford Manor and a key Brunner Mond director.

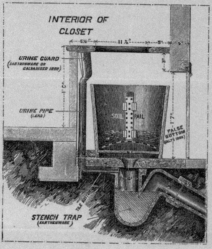

By Her Majesty's Royal Letters Patent,

No. 3594, A.D., 1879, ORIGINALLY.

AND

No. 1429, A.D., 1881, AS IMPROVED.

Also Patented in the United States, Canada, France, Belgium, and Germany.

TURNER & ROBERTSHAW'S
PATENT
DIVIDABLE CLOSET, OR IMPROVED PAIL SYSTEM.

The above arrangement is clean, compact, and effective. The solid matter is effectually separated from the liquid, and bad smells thereby prevented.

For further information address :—

TURNER AND ROBERTSHAW,
SANITARY ENGINEERS,
51, BURY NEW ROAD,
MANCHESTER.

Stench trap and pail system, 1881. (© Wellcome Library)

In order to reduce water contamination (and thereby eradicate typhoid) better sewage systems were clearly needed in the Northwich area. In 1901, the sanitary expert Baldwin Latham proposed to build a totally new sewage system for the whole of the Northwich District, at the cost of nearly £27,000. Northwich Urban District Council rejected many of these proposals, partly because they believed Witton's sewage arrangements were good

enough as they stood. Instead, only a part of Latham's scheme was given the go-ahead, at a cost of £10,000. Henceforth, Northwich's sewage improvement schemes were conducted on a piecemeal basis. The Wallerscote sewage pumping station was completed in 1902, but was only able to process sewage from the higher level parts of Northwich. At lower-lying levels of the central Northwich area, raw sewage was still being pumped into the River Weaver and the Dane, and during periods of flooding, effluent flowed onto the streets. This significant public health hazard was only ended when the Dock Road Pumping Station became operational in 1913. Dock Road's Edwardian engineering was really something of a technological marvel, able to pump over 9,600 gallons of waste matter an hour away from the Weaver, and upwards to the Wallerscote station.

Dock Road
Edwardian Pumping
Station.

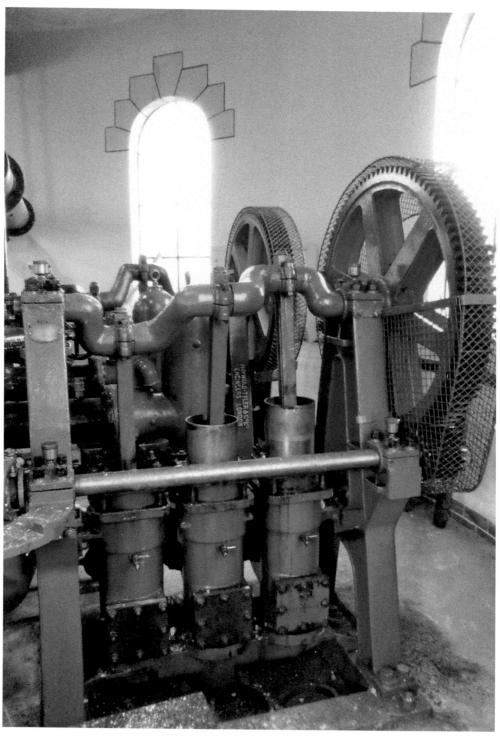

Original Hayward-Tyler machinery inside Dock Road.

Original
pumping
machinery – still
in working order.

Although improvements to sewage systems helped eradicate typhoid, other highly contagious diseases such as scarlet fever and diphtheria (spread from person to person via sneezes and coughs) were diagnosed regularly in the Northwich area. In 1898, Dr Garstang recorded eighteen cases of scarlet fever in Marston and Wincham alone, and there were further serious outbreaks during the early 1900s. There were also outbreaks of diphtheria in Hartford during 1898 (to add to the calumny of other woes afflicting the village at this time) and as late as November 1939, seven child evacuees from Salford, billeted in Sandiway, were hospitalised with the disease.

Smallpox, measles and tuberculosis also had a considerable impact on the Northwich population. Outbreaks of smallpox were reported in Barnton during 1904, and in 1908, a virulent outbreak of measles closed down two national and three council schools in the Northwich area.

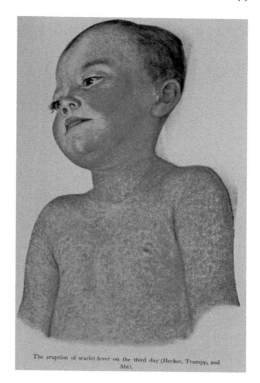

Picture of child with scarlet fever, 1911.
(© Library of Congress)

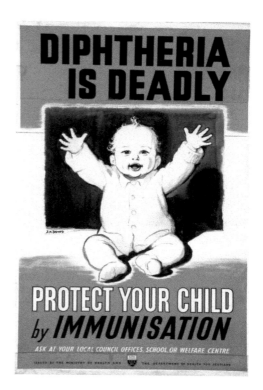

Diphtheria poster by J. Dowd.

Did You Know?
The local population – particularly babies, children and the elderly – were also afflicted, on a regular basis, with serious cases of erysipelas, which was a bacterial skin infection sometimes known as St Anthony's Fire. In 1898, Dr Garstang recorded eighty-six such cases of erysipelas in the Northwich District.

Hospitals

Northwich Workhouse's fever wards had been operational since the 1850s. However, the cocktail of sometimes deadly diseases present among the population of the Northwich area meant that other hospitals, with different specialisms, were also needed during the following years. The Northwich & District Isolation Hospital, at Davenham, became fully operational in 1905. The new hospital's first medical officer was Dr Moreton, from Middlewich, and its purpose was to cater for patients with a range of infectious diseases (excluding smallpox). The driving force behind the building of the new hospital, constructed on high ground near the River Weaver, was undoubtedly Cheshire County Council.

The new hospital was completed in the teeth of considerable opposition from some members of the Northwich Rural District Council, and from the Cheshire Chamber of Agriculture. Some of these members felt that the hospital, funded by an original grant of £2,000 from the county council, in 1903, wasn't needed, and would never be used. By September 1909, the error of such views was plain for all to see – the hospital was full to capacity, with extra blocks having to be built to cater for increased demand. Indeed, the Davenham Isolation Hospital was at the heart of some heated inter-town rivalry between Northwich and Winsford during autumn 1909. Members of the Northwich Urban District Council (NUDC) criticised the inhabitants of Winsford for monopolising the new hospital since its opening in 1905. During September 1909, there were twenty-two Winsford residents housed in the hospital, mostly suffering from scarlet fever, with another five or six Winsford inhabitants based in hastily constructed additional blocks. The hospital was so full of Winsford people (at least according to some NUDC members) that six Winnington infectious disease cases – all from the same house – couldn't be accommodated due to lack of space. In the opinion of many council members, Winsford patients should have been self-isolating at home, rather than filling up beds in the Northwich Isolation Hospital.

Inter-town rivalries apart, the Northwich Isolation Hospital continued to fulfil a vital medical function for scarlet fever, diphtheria and other patients until well into the late 1930s. After the Second World War, however, the significance of the institution declined. The need for infectious disease hospitals was no longer quite so acute, and the institution was transformed into a maternity hospital, before finally closing in 1980. A few isolated outbuildings still remain (which form part of the Davenham Care Centre) – relics of a now largely forgotten institution which once played a key role in the area's fight against infectious diseases. County council funding for the Isolation Hospital had been allocated

on condition that smallpox wasn't treated at the institution – presumably, this was because there was a specific smallpox hospital already in existence, at Marbury, just to the north of Northwich township.

The Marbury Smallpox Hospital was constructed between 1885 and 1895, and was in existence for roughly sixty years before it was demolished at some point between 1955 and 1965. Increasing numbers of patients were referred to Marbury during the year 1903-4, following smallpox outbreaks in Barnton and elsewhere. Once the patients were lodged within the smallpox hospital, they were not allowed to leave until officially discharged by a responsible doctor. Those that did try to abscond from Marbury were hunted down and returned to the institution. In March 1903, for example, a woman named Emily Wedge, aged thirty-six, escaped from Marbury in order to see her child, who was living at a local lodging house. She was pursued, within an hour, by Mr Potts, a local sanitary inspector, who traced Emily to her child's lodging house and detained the mother in a room of the house until she could be carried, kicking and screaming, to a nearby cab, where she was hurriedly returned to Marbury Hospital. During the journey back to the hospital, an apparently drunken Emily smashed the window of her cab and screamed 'murder, murder' at astonished passers-by as she was returned to her bed at Marbury. Emily Wedge ended the day by absconding yet again, in order to see her child. Smallpox was a highly contagious disease that attacked the body's immune system. It had unpleasant symptoms such as acute abdominal pain and vomiting, so it was no surprise that such determined efforts were made to 'capture' Emily Wedge before she could infect other people.

Did you know?
Even Marbury Hospital staff were afraid of contracting smallpox. On 29 October 1904, a patient named Margaret Hall died from the disease at the hospital. By 4 November, some nursing staff were still refusing to touch or move Margaret's body because of the fear of infection. The *Manchester Evening News* reported the incident under the headline 'The Smallpox Hospital Scandal at Northwich'.

A few miles to the south-west of Marbury Smallpox Hospital lay the substantial Georgian mansion of Hefferston Grange, near Weaverham. The mansion was turned into a TB sanatorium by Warrington County Borough Council in June 1921. TB was (and still is) a virulent disease that generally affects the lungs, but can affect other parts of the body as well. The infection is spread from one person to another through the air, when someone with active TB in their lungs coughs, speaks or sneezes. As a result of the ease with which TB could be spread, it's logical to see why sanatoriums such as the one at Hefferston Grange were created. Historically, the disease afflicting those admitted to the Grange was often referred to as 'consumption' because of the extreme weight loss experienced by patients. There were many other symptoms as well, including fever, chills, fatigue and the coughing up of sputum and blood.

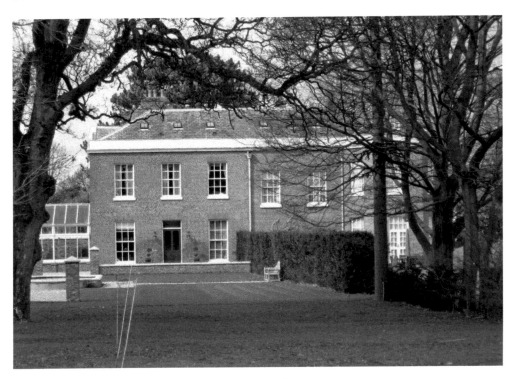

Rear view of Hefferston Grange. (© Dr Duncan Pepper)

The Hefferston Grange Sanatorium was started from scratch in 1921 and, as a result, Warrington Council's Health Committee sent out tenders for companies to supply everything from bedding, crockery and furniture, to lawn mowers and a motorised ambulance. The experiment of creating a totally new TB sanatorium in the area was clearly a success, because the institution was still in existence thirty-four years later, in 1955, when it sought to recruit staff who specialised in the treatment of pulmonary TB for both children and adults. Nevertheless, as the use of vaccines, antibiotics and early screening procedures became more common, the need for TB sanatoriums like Hefferston Grange was certainly reduced. The Grange Hospital, Weaverham, as it became known, was earmarked for other purposes within the NHS, and it ended its days as a unit specialising in geriatric care, before being finally sold to property developers in 1986. By the end of the twentieth century, the Northwich area's three most significant isolation hospitals – Hefferston Grange, Davenham, and the Marbury Smallpox – had long since vanished from the scene. The Victoria Infirmary, on Winnington Hill in Northwich, however, still survives, well into the twenty-first century.

The Victoria Infirmary, which first opened its doors to patients in 1887, has been functioning continuously for 130 years. It began as a voluntary hospital, treating local people for a variety of ailments, and it was never intended to act as a frontline hospital in the area's fight against infectious diseases. Even so, when the Infirmary was expanded in 1905, in a scheme that cost £5,000, it was provided with two isolation wards, along

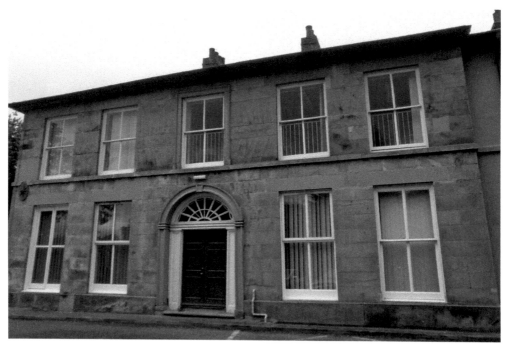

Winnington Bank Mansion.

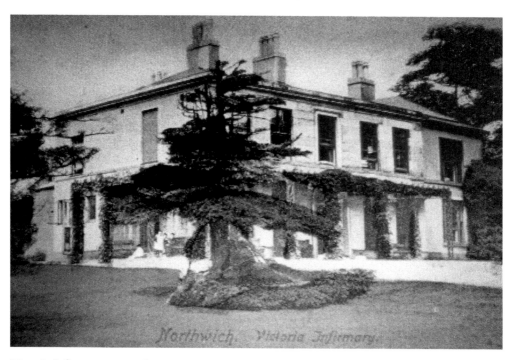

Victoria Infirmary postcard, 1905.

with enhanced male wards and a nurses' duty room. The Infirmary has always been a small-scale, cottage-style hospital, treating relatively low numbers of people. In the seventeen years between 1887 and December 1904, just over 2,000 patients were treated there. These patient numbers increased as the hospital expanded, so that by the years 1913 to 1914, 553 patients were treated at the Infirmary, and the average daily bed occupancy rate was nineteen.

As late as 1960, the Victoria Infirmary was described as being a surgical and casualty hospital with a capacity of just forty-seven beds. Despite its small scale, the Victoria Infirmary still occupies a major place in any history of health in the Northwich area. It was largely the creation of members of the Verdin family, who dominated economic life in Northwich during the late nineteenth century (along with Ludwig Mond and the Brunners). Robert Verdin bought the Winnington Bank mansion, which was transformed into the hospital, and donated it to the town just before his death in 1886. In what was obviously a labour of love for the Verdin family, Robert's brother, Joseph Verdin, acted as president of the Management Committee of the Victoria Infirmary for well over twenty-five years. Even after Joseph was knighted, became a baronet, and relocated to Garnstone Castle in Hertfordshire in 1900, he still raced back to Northwich to chair meetings of the hospital Management Committee. Another brother, William Verdin, was a life governor of the hospital, and Joseph and William's sister, Mary Verdin, was appointed president of the hospital's Ladies Committee, which oversaw management of nursing policies within the institution. During the 130 years of its existence, more local people have undoubtedly been treated at the Victoria Infirmary than at Hefferston Grange, Marbury and Davenham Isolation Hospital combined. Without the input of Joseph, William and Mary Verdin, however, it's likely that the Victoria Infirmary would have had a very different history.

Joseph Verdin, from the Verdin Technical Schools, 1897.

7. Queen Victoria's Wars

The impact of the First and Second World Wars upon the people of Northwich and around has been much studied. Less attention has, however, been focused upon the impact of earlier wars of the Victorian era. These earlier Victorian conflicts, such as the Crimean War, the Sudan Wars of the 1880s and 1890s, and the Boer War of 1899–1902, all had some impact upon the people of Northwich and around. In particular, the Boer War, fought between Britain and the Dutch Boer settlers of the Transvaal and the Orange Free State, in Southern Africa, was the most controversial war of the entire Victorian era. It divided opinion in Northwich and across Britain. Nevertheless, as will be seen, the war attracted strong support in the Northwich area, and as the *Manchester Evening News* pointed out in an article of 20 August 1906: 'Northwich claims to have sent more men to South Africa, in proportion to its size, than any other district.'

A Crimean Homecoming

Edward Townshend was just eighteen years old when he left Wincham Hall to fight in the Crimean War, as a lieutenant in the 46th Foot (South Devonshire Regiment). He was subsequently present at most of the war's major engagements, including the Alma, Balaklava, Inkerman and the siege of Sevastopol. Townshend was hospitalised for a short period during the war with rheumatic fever, but he returned to fight at the battle of Inkerman, where the 46th Foot suffered particularly heavy casualties, and its divisional commander, Sir George Cathcart, was killed while leading a charge against the Russians.

Once the war against the Russians was over, Townshend travelled back to England, arriving by train at Hartford station on Thursday 24 April 1856. Here, he was greeted by a large and enthusiastic crowd of well-wishers. Indeed, large crowds lined the whole 4-mile

Victorian
Wincham Hall.
(© Wincham Hall)

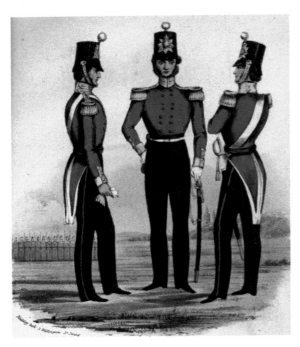

46th Foot officers' uniform, *c.* 1851.

46th Foot colours, by Richard Cannon, 1851.

route between Hartford station and Townshend's home at Wincham Hall. Flowers, flags, laurel wreaths and banners adorned the entire route taken by Townshend and his father. The hoteliers and alehouse owners of the area were certainly aware of the advertising potential offered by such an occasion. Mr Burgess, of the Angel Hotel, provided four magnificent grey horses for the open-topped carriage that conveyed Edward Townshend and his father from Hartford to Wincham. Other businesses, such as the Crown Hotel, the Green Dragon and Witton Brewery, also paid for printed banners to be produced, which were then hung across the route of the Townshend procession. In what must have been an extremely long procession, eighty Cheshire Yeomanry cavalry troopers followed the Townshend carriage, and they in turn were followed by countless gigs, hansoms and other carriages driven by a multitude of farmers, tradesmen, gentry and other local people. Gas jets were lit at the Northwich Navigational Arch, and fireworks were set off at the arch, the Angel Hotel and at Wincham Hall. To cap the festivities, cannons were fired from the hall, and free ale was provided for the yeomanry, who gathered for the evening (along with a huge crowd) in the grounds of the Townshend home. All was not levity and lightness during the day of the festivities, however. The crowds, and Townshend himself, were well aware of the privations of the troops in the Crimea, and repeated references were made to the hardships of life in the trenches outside Sevastopol. One of the banners produced to greet Townshend's return to Northwich proclaimed: 'fortune favours the brave.' Good fortune certainly did come to the already wealthy Lieutenant

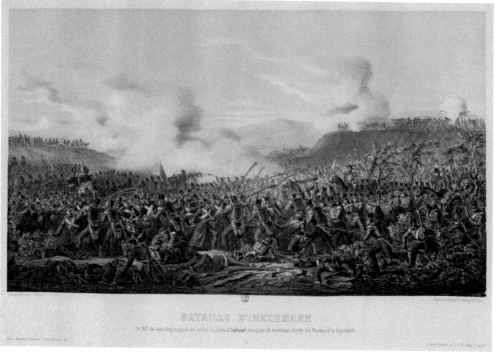

Battle of Inkerman. (© National Library of France)

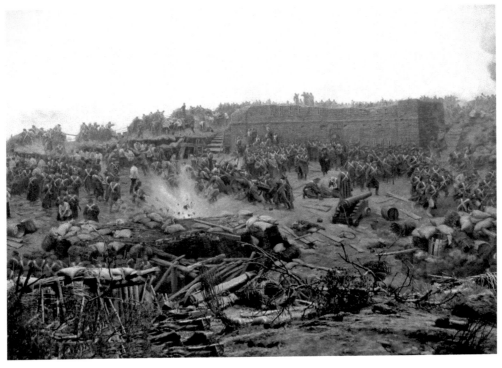

Siege of Sevastopol by Valentin Ramirez, 1854–55.

Townshend processional banners.

Townshend, when he married Alicia Parr from the rich local Parr banking family, in 1867. Long life, however, managed to allude the Northwich Crimean War veteran, who died at the comparatively young age of forty-nine, in 1886.

The Neufelds & the Sudan Campaign

In 1898, Charlotte Neufeld (née Netherton) was appointed as the matron in charge of Northwich's Marbury Smallpox Hospital. Charlotte had previous nursing experience, acquired in Greece, spoke a number of languages, and would undoubtedly have made a positive impression during her interview for the Marbury post. Her interesting past, and marital situation, would also have been the subject of discussion at the time of her appointment. Though she clearly looked upon herself as being married, she hadn't actually seen her Austrian husband, Charles Neufeld, for over eleven years. Charlotte had married Charles in Cairo in 1880, and their daughter, Evelyn, was born later in the same year. Mr Neufeld worked as a civilian contractor for the British army in Egypt, and in 1887 he disappeared during a trading expedition to Khartoum in the Sudan. Everyone, probably even Charlotte herself, assumed that Charles Neufeld was dead – another victim of the Mahdist War that disfigured Egypt and the Sudan during the 1880s and 1890s.

Did You Know?
The Mahdist Wars that so disrupted the Neufeld family lasted from the mid-1880s until 1898. The Dervish followers of the Mahdi, Muhammed Ahmed, launched a fundamentalist Muslim war against foreign influence, and in 1885 they sacked the city of Khartoum and slaughtered its entire garrison (killing General Gordon, the British commander, in the process). A British army had been sent to save Gordon and Khartoum, but failed to arrive in time. This army then withdrew to Egypt, and for the next thirteen years, the Dervishes were largely left in control of the Sudan.

In 1898, the British again invaded the Sudan, under the command of General Kitchener, in order to reduce the threat from the Dervishes. Kitchener's forces inflicted a decisive defeat upon the Dervish forces of Khalifa Abdullah Al-Taashi (the Mahdi's successor) at the battle of Omdurman, in November 1898, which finally brought the Mahdist Wars to an end. After Omdurman, European prisoners of the Dervishes were released, and one of the released men was none other than the long-lost Charles Neufeld.

When Charlotte received the astonishing news that her husband was still alive, she raced from Northwich to Egypt, with her daughter (who also worked at Marbury Hospital) in a journey that attracted newspaper headlines around the world. There was, however, to be no happy ending to this particular wartime story. Charles Neufeld wrote books about his imprisonment in the Sudan, and he toured Britain giving accounts of his harsh treatment at the hands of the Khalifa. Charlotte, though, was largely absent from these book tours. Stories soon began to circulate that Charles' treatment at the hands of the Dervishes had

Neufeld in captivity.

Neufeld's desert home while in captivity.

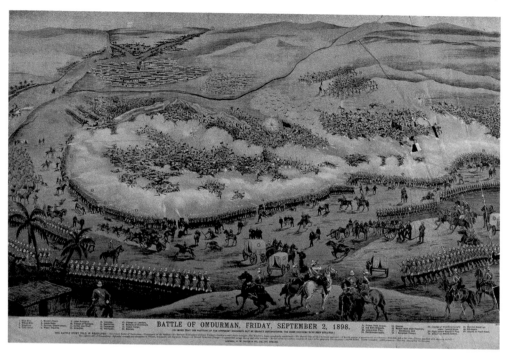

Battle of Omdurman, 1898. (© Wellcome Library)

Charles Neufeld promoting his book
(without Charlotte) in 1899.

not been as brutal as once thought. Indeed, though he might have been shackled and imprisoned for a short period, later on he seems to have moved about Khartoum with some freedom. Charles Neufeld married a Sudanese woman during the period of his captivity, and he sent her money once he was back in British hands. Allegations were also made that Charles had taught the Dervishes how to make gunpowder and fire guns. Much had obviously changed during Charles and Charlotte's long period of separation, and a permanent reconciliation was probably unlikely. Charlotte never returned as matron of the Marbury Smallpox Hospital, and there is a record of a Frau Charlotte Neufeld landing in New York as an immigrant, at some point after 1906. Charles Neufeld, however, became a political agent, based in the Middle East, and died in Germany in 1918.

Northwich and the Boers

A clash between the British, who were intent on expanding their empire in Southern Africa, and the independent-minded Boer farmers, was probably inevitable. When the Boer War began in 1899, the initial military consequences for the British were disastrous. The key towns of Mafeking and Ladysmith were besieged by the Boers, and British forces were defeated at Spion Kop, Colenso and the Tugela River. In order to reverse these early military defeats, men from Northwich, the rest of Britain, and from around the empire flocked to the colours in order to fight the Boers in South Africa. At a meeting in late December 1899 at the George and Dragon public house in Great Budworth, thirty-six members of the Earl of Chester's (Cheshire) Yeomanry volunteered to go and fight in South Africa. The men at the meeting were all members of C Squadron (Arley and Bostock) of the Yeomanry, led by their commanding officer, O. M. Leigh of Belmont Hall.

George & Dragon public house, Great Budworth.

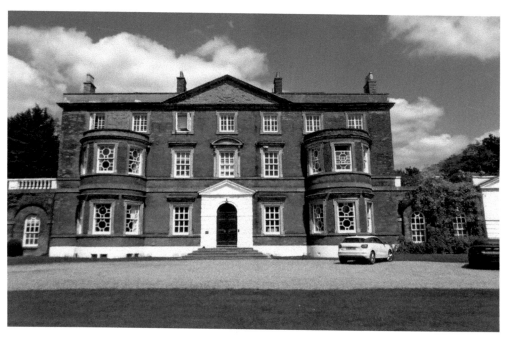

O. M. Leigh's home at Belmont Hall, Great Budworth.

Cheshire Yeomanry (full dress
uniform) *c.* 1890s. (© Chester
Military Museum)

In early January 1900, eight reservists were given a rousing send off from Northwich railway station by large crowds as they left to join the troopship *Braemar Castle*, docked in Southampton, which later took them to South Africa. The reservists were led by Corporal Edward Leather, from Castle, Northwich, who was a local footballer and an employee of Brunner Mond chemical works. All eight men were joining the 2nd Battalion of the Cheshire Regiment. One of the reservists was a postman, another (Harry Wibberley) was a policeman, and there was at least one other Brunner Mond employee present, in addition to Leather.

Did You Know?
Edward Leather was promoted to the rank of sergeant while in South Africa. He and other Northwich soldiers in the Cheshire Regiment formed part of the Johannesburg Fort garrison. The fort was captured from the Boers in 1900. Subsequently, Leather participated in, and led, weekly patrols from the fort, which penetrated deep into Boer territory.

Cheshire Regiment soldiers in Johannesburg Fort, 1901. (© Rijksmuseum)

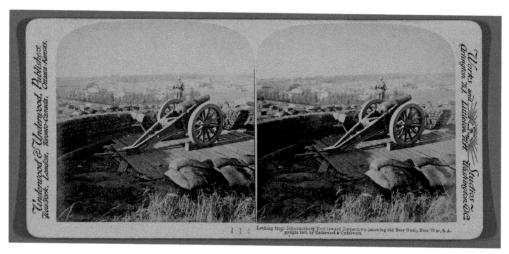

A view from the fort showing captured Boer gun, 1901. (© Rijksmuseum)

A modern view of the fort, with blue plaques commemorating the Cheshire Regiment garrison. (© The Heritage Portal)

Professional soldiers from the more affluent parts of Northwich also fought in South Africa. Guy Reynolds, who lived at Whatcroft Hall, was a scion of the Cheshire Hunt, and a captain in the Dragoon Guards. He survived the siege of Ladysmith, and in August 1900 he led twenty of his men in a surprise attack on 100 Boers at Kotze's Drift, on the Buffalo River. Reynolds received many plaudits for this action, during which he was wounded, and the skirmish was reported in newspapers across Britain. Another local man, David Lea Jones, from Grovemount in Davenham, was the lieutenant-colonel in command of the Cheshire Regiment's 3rd Battalion in South Africa. The war fought by Lea Jones, Reynolds, Leather and the other Northwich men was certainly controversial. There were few pitched battles. Instead, both sides conducted a largely guerrilla war of ambushes and sabotage. To win, the British resorted to burning down Boer farms, seizing livestock and placing Boer families in what turned out to be the world's first concentration camps.

Despite the controversial nature of the war, back in Northwich the troops received considerable support. The local MP, Sir John Brunner, was an implacable opponent of the war, and in an October 1900 speech he stated that the Boer War '[wasn't] worth the bones of one gallant Cheshire boy'. Even so, a number of his own Brunner Mond employees went off to fight the Boers, and were given leaving gifts and presents by their fellow workers. Northwich Urban District Council was also in the forefront of activities designed to support local troops in South Africa. Its officials accompanied the reservists to Northwich station, and it supported fundraising activities to support soldiers' dependents and Christmas dinners for soldiers' families. The council's clerk, Arthur Rowley, was surely one of the unsung heroes of early twentieth century Northwich history. He organised much of the council's troop-supporting activity, and kept in touch with both the War Office and Edward Leather. Information about the Northwich contingent in the war was relayed to Arthur Rowley by Leather, and this was then passed on to families, and to the *Northwich Guardian* newspaper. Sixteen years later, during the First World War, Rowley was still in post, and still doing what he could to help the dependents of local soldiers (this time fighting on the Western Front).

Ultimately, at least fifteen Northwich men died during the Boer War. Most of the fatalities were due to disease, though a few died as the result of wounds received in battle. The bronze memorial tablet dedicated to the memory of these men – unveiled at St Helen's Church by Colonel Sir Thomas Marshall on 19 August 1906 – can still be seen today, and acts as a fitting reminder of the human costs of Britain's long imperial past.

Boer War Memorial, St Helen's Church. (© Kate Andrews)

St Helen's Church. (© Kate Andrews)

Bibliography

British Newspaper Archive, www.britishnewspaperarchive.co.uk

Coates, K. (ed.), *Tom Mann's Memoirs* (Spokesman, 2008)

Goulden, J., *Davenham 900+ Years of Work and Worship* (John Goulden, 2017)

Higginbotham, P., workhouses.org.uk

Hodgman, C. and S. Shave, *History Explorers: Life in the Victorian Workhouse* (BBC History, 2015)

James, R. W., *To the Best of our Skill and Knowledge: A Short History of the Cheshire Constabulary* (Museum of Policing in Cheshire, 2005)

Koss, Stephen E., *Sir John Brunner: Radical Plutocrat 1842–1919.* (CUP, 1970)

Montgomery, B. L., *A Concise History of Warfare* (Collins, 1972)

Northwich History, northwichhistory.co.uk

UCL, Summary of Individual Legacies of British Slave Ownership, ucl.ac.uk

UWE, The Poor Law Relief System, humanities.uwe.ac.uk

Acknowledgements

The authors would like to thank the following people and institutions for their help in producing this book: staff at Davenham Hall, Davenham Primary School, Wincham Hall, the Max Planck Institute Rome, the Museum of Policing in Cheshire, Catalyst Widnes, Cheshire Constabulary, Weaver Hall Museum, United Utilities, Linda Stockton at Winnington Hall, the Law-Lyons family, Richard Leigh, Kate and Wendy Andrews, St Wilfrid's Church, and Mike Amesbury MP.

Every effort has been made to fulfil requirements with regard to reproducing copyright material. The authors and publisher will be glad to rectify any omissions at the earliest opportunity.